THE
Jack the Ripper
LOCATION
PHOTOGRAPHS

THE
Jack the Ripper
LOCATION
PHOTOGRAPHS

DUTFIELD'S YARD AND THE
WHITBY COLLECTION

PHILIP HUTCHINSON

AMBERLEY

First published 2009

Amberley Publishing Plc
Cirencester Road, Chalford,
Stroud, Gloucestershire, GL6 8PE

www.amberley-books.com

British Library Cataloguing in Publication Data.
A catalogue record for this book is available from the British Library.

ISBN 978 1 84868 784 4

Typesetting and Origination by Amberley Publishing.
Printed in Great Britain.

Contents

About the Author

Philip Hutchinson is the author of several history books, amongst them *The London of Jack The Ripper Then and Now* (Breedon Books, 2007), co-authored with Robert Clack. An actor by profession, he is now one of the world's best-known and respected Jack the Ripper tour guides in London. He has lectured on aspects of the case in the UK and USA and has featured many times on TV, radio and podcasts discussing the Ripper. In 2007, he twice had the fortune to acquire extremely important and previously unknown photographs of the murder locations, which form part of his extensive collection of true crime ephemera. Philip has been a Council Member of the world's oldest paranormal organisation, The Ghost Club, since 2001 and has for some years also played the role of emcee for The Whitechapel Society 1888. He lives in Guildford, Surrey.

Introduction

This is not a book about Jack the Ripper. The available canon of Ripperological literature runs into three figures. This modest work concerns two sets of photographs, unrelated except for their subject matter, and taken sixty years apart. Some of these images were first published in the book I wrote with Robert Clack, *The London of Jack the Ripper Then and Now*, (Breedon Books, 2007) but others have previously only been seen publicly at lectures and are published here for the first time.

This is also not a book that will become a best-seller. Its demographic is marginal and the issues covered will only appeal to a limited number of those individuals.

Having moved on from generic knowledge of the case, many students of Ripper history now concentrate on other areas. A good proportion are interested in contemporary images of the East End of London and especially those locations with connections to the sequence of brutal murders that occurred in 1888. Although historical information is still being uncovered (albeit that it is widely acknowledged a 'Eureka!' moment is highly unlikely), some of the most exciting discoveries in research in the last few years have been photographic. I am fortunate indeed that I find myself the owner of many of these images.

I am the first to admit that the term 'expert' is relative and few in the field would class themselves as such. It has been a constant source of bewilderment to me that I have any standing amongst serious Ripper historians as I truly feel dwarfed in my understanding of the case compared to many of my associates, a good deal of whom have never published anything, but whose skills give flesh and bones to the writings of we others. The list of acknowledgements overleaf will bear testament to the fact that research is best undertaken in a pack.

In the first half of this book, you will find reproductions of every image from The Whitby Collection along with modern-day comparison shots. The known story of the life of the photographer is discussed. Following this, there is a detailed account of the painstaking research that went into the verification of an image some have cited as the most important photographic discovery in the case for twenty years, taken by one of the first Ripper Tourists when Queen Victoria still sat on the throne.

This book is dedicated to Margaret and Norman, and to Larry – the people from whom I obtained these photographs. Without them, you would not be able to see what you are about to see. I further wish to publicly offer my thanks to Brenda and Ed in Maryville, Tennessee, for their support and presence when I lectured on the case in the US in 2008.

Philip Hutchinson, Guildford, August 2009

Acknowledgements

I wish to give my thanks to the assistance and research skills of a large number of Ripper historians, and to individuals from organisations, who assisted (or offered to assist) me in my endeavours. They are, alphabetically:

Debra Arif, Paul Begg, Neil Bell, Tony Brewer, Robert Clack, Mike Covell, Ellen Engseth (UWM Libraries, Milwaukee), Stewart P Evans, Martin Fido, Chris George, Paul Gjenvick (Gjenvick-Gjønvick Archives), Margaret and Norman Green, Dee Anna Grimsrud (Wisconsin Historical Society), Jeff Korman (University of Baltimore), Larry Lingle, Jake Luukanen, Pete McClelland, Al Muchka (Milwaukee Public Museum), John Nondorf (Wisconsin Historical Society), Dr Timothy Riordan, Thomas Schachner, Chris Scott, Neal Sheldon, Jonathan Shorr PhD (University of Baltimore), Paul Smith (Thomas Cook Archives), Geraldine Strey (Wisconsin Historical Society), Dennis Weidner, Tom Wescott, Gareth Williams.

John Gordon Whitby

In the summer of 2000, I took a holiday in Lincoln. It was a type of package holiday organised by an elderly couple who ran a company providing educational historical excursions to parts of England. The holiday was not the most interesting of events and seemed to be comprised almost solely of long-retired couples lacking in any social skills. Given the option of attending a slide show about the town of Stamford or venturing out by myself, I chose the latter and left the building to attend Lincoln's Ghost Walk.

Margaret Green has run these popular walks in the city for some years and once escorted Tom Hanks on a private tour whilst he was filming *The Da Vinci Code* in Lincoln Cathedral. Not only did I find her guiding infinitely more engaging than the uninspired mutterings of the holiday organisers but we struck up an instant rapport and I stayed in touch once her tour was over.

I have been a Council Member of the world's oldest paranormal organisation, The Ghost Club, since 2001 and, as Events Officer, it is my responsibility to book speakers on the subject of ghosts and hauntings for the group's monthly lectures in central London. Thus it was that, having met with Margaret and her husband Norm in Lincoln a couple of times since 2000, I booked her to speak in April 2007.

Before the talk began, we sat in the venue's bar to catch up on the year's respective gossip. In passing conversation Margaret commented that she had found something in her kitchen drawer at home that may interest me. Knowing that I was already by that time a Jack the Ripper tour guide of some years standing in the East End, she said that her uncle had taken some photos of locations connected to the crimes in the 1960s and wondered if I would like to see them. The gap between the end of her question and my reply was almost impossibly short.

Within days, a padded envelope fell through my letterbox, sent Recorded Delivery. As I walked down a Guildford hill on my way to work, I ripped the packaging open to find a cheap blue 24-page photo album inside. A label stuck on the front, in Margaret's handwriting, bore the words '*Views of where Jack the Ripper killed his victims taken by JOHN G WHITBY*'. As I flicked the album open, I found a modern press cutting about the murders cut from a broadsheet and a set of ten cream-coloured envelopes. All the Basildon Bond envelopes were yellowing

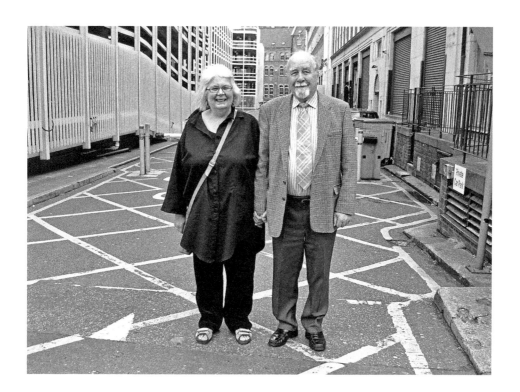

Above: Margaret and Norman Green at the entrance to the service road that was once Dorset Street, June 2009

Right: The photograph album that contained The Whitby Collection

with age and all had clearly been written upon in black ink at the same time. The first envelope in the series read '*looking towards Dorset ST from Thrawl st*'.

On pulling out the envelope and flipping it open, I found a well-composed and sharp (but clearly amateur) image of a familiar location, yet seemingly bereft of any traffic. It was the corner of Thrawl Street and Commercial Street in Whitechapel, looking north towards Duval Street (as Dorset Street was renamed in 1904) and things were only to get more exciting as I inspected the contents of the envelopes that followed, so much so that I could actually feel my fingers tingling as I saw them for the first time.

When I got back home that night, I immediately phoned Margaret and, upon request, she agreed to sell me the photographs and the rights to them on condition her name was credited on each reproduction and she was kept informed each time they were to be used in a book or publication.

John Gordon Whitby was born to Walter and Gertrude in March 1911. He had three brothers; William Guy (known as Guy, and Margaret's father, born in 1908), Walter Terence (known as Terry, born in 1909), and a third brother who tragically died shortly after birth; a nurse decided that the infant needed some fresh air and opened a window, at which point the baby turned blue and quickly expired. John was himself seriously ill as a child and, until the age of nine years, was largely confined to a wheelchair.

John's father, Walter Herbert Whitby (born in 1881), was a Mason and held an important position as the Head of Housing for Hull Council. He was also an organist and played before King George VI and Queen Mary. Together with Gertrude (born in 1880) he gave piano lessons, yet curiously the couple never taught their sons how to play an instrument. John's uncle was G. Stafford Whitby. He owned a rubber plantation and wrote several books on the processing of the material in the second quarter of the twentieth century. He was also responsible for publishing the collected papers of Wallace Hume Carothers, the inventor of nylon.

The family eventually moved into a comparatively modest council house at 123 Boothferry Road in West Hull. The building still stands. The area dated from the late Victorian period when Hull was inundated with tradesmen and needed to expand. It was initially a toll road leading from the more famous Anlaby Road, which stretches towards Ferriby and the villages of the Humber Estuary. A golf course had previously stood on the site but was cleared for the building scheme in 1927. Some Victorian houses from the time of the toll road remain, but most are from the later construction work. The road was built to provide a link between Hull and Goole, itself become a thriving port. Work was completed by 1929. The name of the road was chosen to commemorate the opening of the Boothferry road bridge over the River Ouse. The bridge replaced a previous ferry service, based at Booth near Howden. West Hull managed to escape the attention of Hitler's Luftwaffe due to its location. The property was sold for £125,000 in 2006, about a quarter higher than

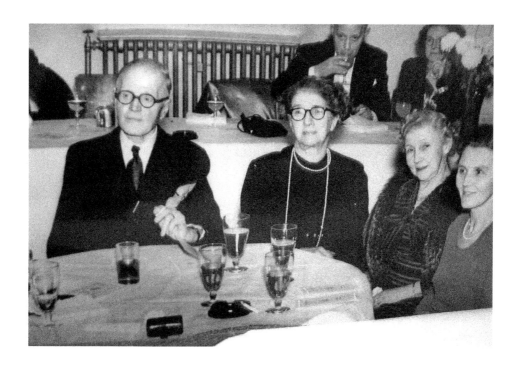

Above: Walter and Gertrude Whitby at a social event. The woman in the fur is the mother of aviator Amy Johnson, who was also from Hull *(Courtesy Margaret Whitby-Green)*

Right: 123 Boothferry Road, Hull *(Courtesy Mike Covell)*

the average house price. Boothferry Road flooded badly during the exceptionally wet summer of 2007. The road still retains its original lines of trees and wide traffic lanes, specifically constructed to bear the burden of heavy goods vehicles.

At the outbreak of the Second World War, John became a navigator in the RAF and during the conflict he found himself based in Egypt and Greece. The only two current known photographs of him date from that time, 20 years before he took the series of photographs in London. Whilst stationed in Egypt, John became engaged to a member of the Egyptian Royal Family. Following his decommission, he returned to Hull and his fiancée began to send him gold ingots through the mail. Not only did Walter disapprove of the potential marriage, but he was also aware that this act of altruism and affection was actually nothing short of smuggling and insisted that the bullion was returned to source. He never married.

 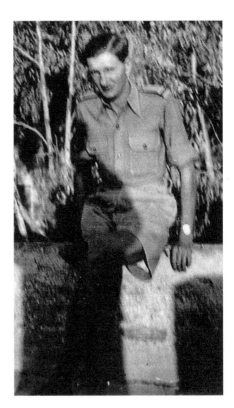

Above left: John Gordon Whitby in his flying gear, April 1941
(Courtesy Margaret Whitby-Green)

Above right: John Gordon Whitby on active service during World War Two
(Courtesy Margaret Whitby-Green)

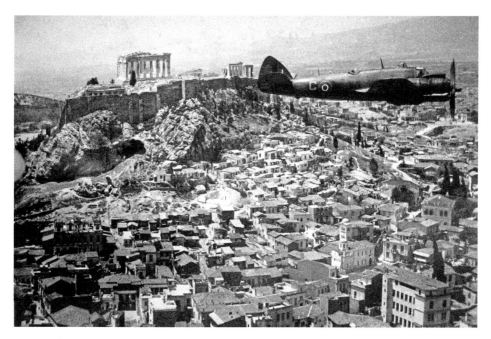

Passing the Parthenon in Greece during World War Two. John Gordon Whitby sits in the navigator's seat in the plane in the foreground *(Courtesy Margaret Whitby-Green)*

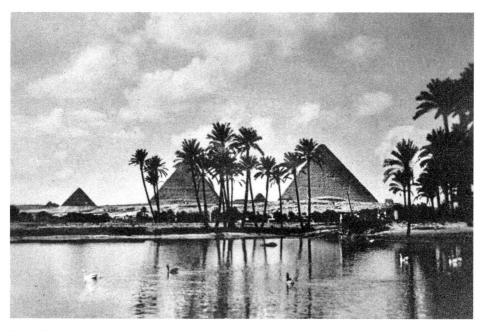

Pyramids on the banks of the Nile, taken by John Gordon Whitby in the Second World War *(Courtesy Margaret Whitby-Green)*

The crossing in Boothferry Road where Walter Whitby was killed *(Courtesy Mike Covell)*

Settling back into civilian life, John became a dental mechanic and continued to live at the Boothferry Road address. He specialised in making false teeth and a great deal of moulds and paraphernalia were kept in the house. John was a very quietly spoken man and had a passion for jazz music. Paradoxically, he also had an interest in bullfighting and had a collection of photographs relating to the subject.

His mother, Gertrude, succumbed to cancer in the late 1950s. In 1962, his father (now elderly) was crossing the road in front of the family home. He was hit by a heavy goods vehicle and killed and the driver responsible for his death was fined just £20. It soon came to light he had killed another pedestrian in a similar manner in 1960.

From this point, John lived at 123 Boothferry Road alone. He and his brother Guy shared an interest in true crime. Their passion covered all aspects of criminal activity, especially trials. It is because of this that the collection of photographs known as The Whitby Collection exists.

John died of cancer in June 1977, whilst Margaret was in hospital giving birth to one of her children. Although a veritable Aladdin's Cave, the house was cleared

within the space of a week to save having to continue paying rent on an unoccupied property. Walter Whitby had owned a Steinway piano and this had remained in the house after his death in 1962. The instrument was sold back to the shop from which it was originally purchased.

Nearly all of John's possessions were disposed of; most things were thrown away. Margaret remembers that John had a very large collection of books and, given his interest in true crime and his clear knowledge of exact locations relating to the Whitechapel Murders, it is disconcerting to consider that amongst the volumes may have been some of the most desirable early books published on the case. Undoubtedly, he would have held copies of Leonard Matters and Edwin T. Woodhall amongst his cache. It is almost unbearable to suggest that an extremely rare William Stewart or Tom Robinson may have ended up in a dustbin – or even some original publications from the period.

Besides two photographs of John and a handful of photographs he took during his time in the RAF, all Margaret possessed of her uncle was his collection of Ripper photographs. During the 1977 house clearance, Guy had found the envelopes and – with a canny realisation of their significance, thankfully made evident by the interest he shared with his late brother – handed them to Margaret as a safeguard, keepsake, and legacy.

This series of images represents all that is known to remain of Whitby's Ripper collection. It is almost certain that he took many more photographs than those that survive but these no longer exist. There are not even any negatives.

However, Ripper research owes a huge debt to John Gordon Whitby. He may be the earliest known example of a Ripper historian and enthusiast taking multiple photographs of the locations who wasn't an author himself.

The Whitby Collection

The collection consists of 27 photographs. Whitby kept them in 10 envelopes and wrote brief notes on the front of each in black ink, presumably shortly after they were taken. 18 of the images measure 5" x 3.5" and the other 9 are 3.5" square. All are gloss photographs with white borders. The set covers at least four different rolls of film (Kodacolor, Kodak Velox – both 3.5" and 5" sizes – and Ilford, though there is the possibility of a fifth roll without a visible backstamp). These will be indicated in the captions. It should also be noted that the photographs were not all taken on the same day, presenting the possibility and likelihood of Whitby making multiple trips to London.

Although appearing arbitrary, the photographs are here presented in the order in which they were originally received by the author. The images are presented with the original flaws intact, at full size, and without any selective cropping. The photographer's grammatical errors from the envelope fronts are retained.

John Gordon Whitby's handwriting on the front of one of the ten envelopes

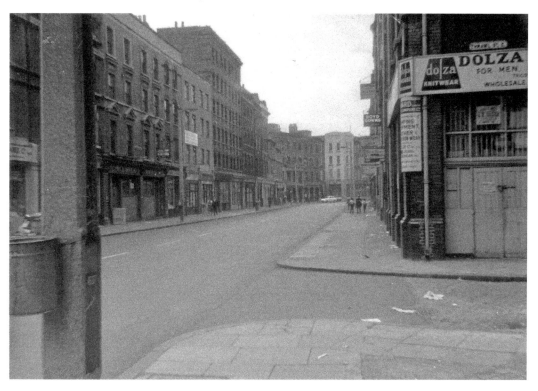

(Courtesy Margaret Whitby-Green)

(Kodak Velox) Unusually for this collection, a few people are visible in the distance on both sides of the street. There is a single car further north, at the entrance to Duval Street. Most of these buildings on Commercial Street still stand, as can be seen in the 2009 image below.

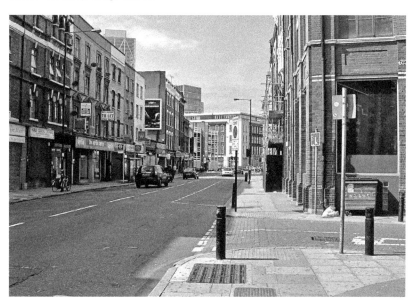

ENVELOPE 2: '2 Views Chambers ST. 2 Views Swallow Grds. As you can see there's not much to see here. Swallow Gardens is nothing but an unused Archway now, Closed at one end.'

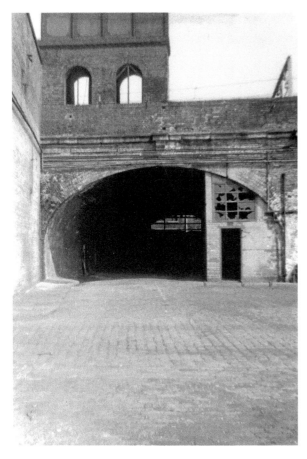

(Courtesy Margaret Whitby-Green)

(Kodak Velox) This view was taken from Royal Mint Street, looking north. Today, the Docklands Light Railway emerges for the first time into the open air in the foreground at this exact spot. This photograph, and those that follow, are intriguing. The murder of Frances Coles at this location on 13 February 1891 is seldom classed as a Ripper killing, although it is generally acknowledged to be the final Whitechapel Murder. Until very recently, the site of Swallow Gardens was incorrectly identified. The sole remaining thoroughfare between Chamber Street and Royal Mint Street is Abel's Buildings, much closer to the junction with Leman Street. There had been an assumption for many years that this must have previously been known as Swallow Gardens. However, recent research showed beyond doubt that it actually lay close to the Mansell Street end, further west. Subsequent closure of the arch and later arrangements of overhead railway lines had made the spot appear inconspicuous. What is striking here is that Whitby was able to identify the correct location over four decades before the rest of the Ripper historians caught up with him. The tower here visible matches with a view from the *Illustrated Police News* from 1891 (the tower itself having been removed some years ago now, perhaps adding to the confusion). Thus only two conclusions can be reached; either Whitby had access to papers and documents not many people had seen at that time (perhaps possessing original copies of the highly valuable Illustrated Police News himself), or he had spoken to locals whose parents – or even themselves – may have recalled the events and could still correctly identify the location. The discovery of this image was a vindication of the research undertaken in modern times.

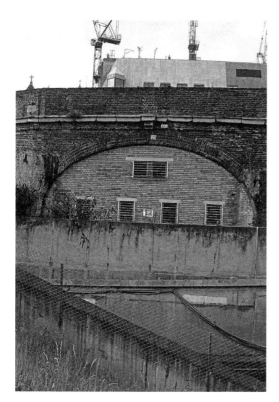

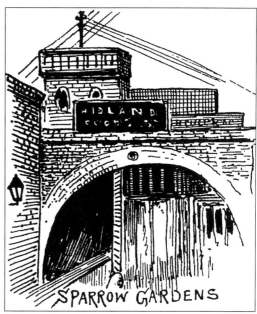

A drawing from the *Illustrated Police News*, February 1891, showing the same view with the tower in place *(Courtesy Robert Clack)*

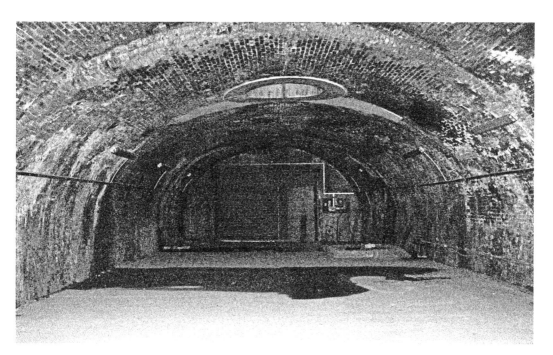

Inside Swallow Gardens in 2009, a spot seldom seen

(Courtesy Margaret Whitby-Green)

(Kodak Velox) Chamber Street looking west towards Mansell Street. Taken into the direction of the sun, this shows the photograph was taken in the afternoon. In comparing the Whitby image and the modern shot, it is obvious that the terrace of old cottages on the southern side have been replaced. Curiously, however, the floor lights in the pavement on the right still exist.

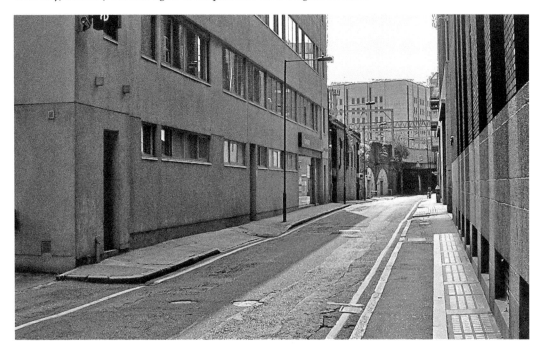

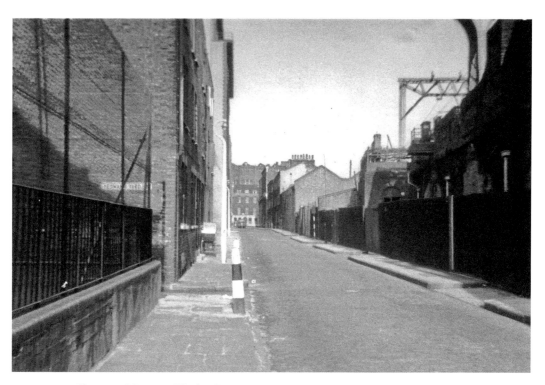

(Courtesy Margaret Whitby-Green)

(Kodak Velox) Chamber Street looking east towards Leman Street. Running off
to the left is Yeoman's Yard. A pram is visible further down the street. This view
has clearly changed a great deal but the double-gabled building halfway down the
street is still in use.

(Courtesy Margaret Whitby-Green)

(Kodak Velox) The entrance to Swallow Gardens from Chamber Street. At the time of Whitby's visits, the site was even more disguised than today. The archway masonry was completely hidden behind fencing. Today, the supporting iron pillar to the right makes it plain that it is the same spot.

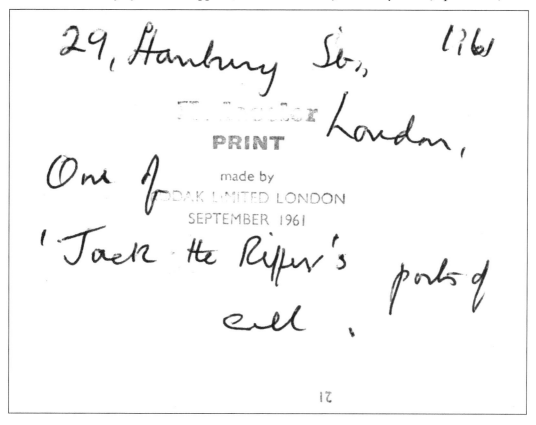

The reverse of the colour photograph of 29 Hanbury Street

(Kodacolor) Backstamped 'Kodacolor Print made by Kodak Limited London, September 1961'. Whitby has also written '29, Hanbury St, London. 1961. One of 'Jack the Ripper's ports of call.' in black ballpoint pen. Furthermore, the number '21' is printed on the reverse of the image, showing this is just one image from a roll. This image is currently the only known colour photograph of 29 Hanbury Street, the murder location of Annie Chapman on 8 September 1888, in existence. As time has passed, the original photograph has faded a little and taken on a yellowish tint. Unusually, the original front door is wide open and this would suggest that Whitby had already gained permission to enter the building before the image was taken. The modern photograph is taken on the same spot which would be totally unidentifiable were it not for the fact that the buildings on the southern side of the street still stand and from the use of old maps it is possible to establish the exact location. The northern side of the street from Wilkes Street to Brick Lane was pulled down early in 1970.

(Courtesy Margaret Whitby-Green)

(Ilford) Three images of the backyard at 29 Hanbury Street. All have Whitby's handwriting on the reverse, stating '1961. 29, Hanbury St, London, (Jack the Ripper)'. However, there is every reason to believe that the last of the three images was taken at a totally different time to the first two. Not only is the handwriting in blue and black inks on the first two images and only in black on the last, but the wooden boards blocking the tops of the archways into the basement have clearly been rearranged in the last photograph. What appears to be drawing on the board at the bottom left is almost certainly trails left by snails and slugs. Lastly, the actual murder spot (between the steps and fence) in the first two images is damp, yet dry in the third. In the first two images it is possible to look into the window right through the building to the street. It is also possible to see that, when Whitby entered the backyard, the front door was closed.

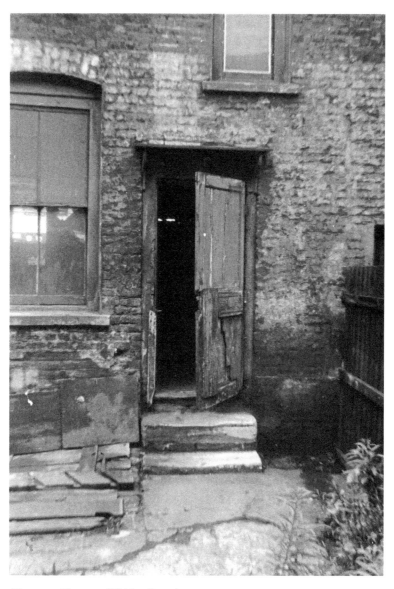

(Courtesy Margaret Whitby-Green)

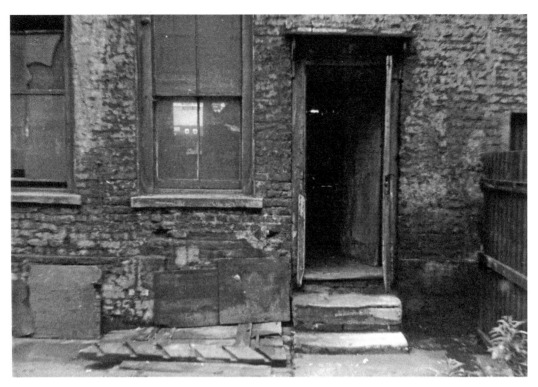

(Courtesy Margaret Whitby-Green)

(Courtesy Margaret Whitby-Green)

ENVELOPE 4: 'The Passage at Hanbury St. 4 Views.'

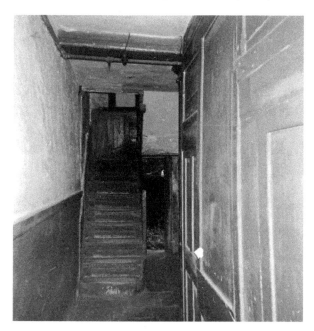

(Courtesy Margaret Whitby-Green)

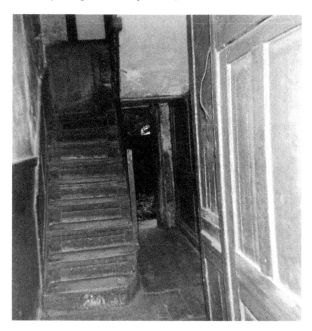

(Courtesy Margaret Whitby-Green)

(Kodak Velox) A series of four fascinating images walking from the front door of 29 Hanbury Street towards the backyard. There is a pipe running along the ceiling and an electric light fitting, without a bulb. There is a photographic flaw on the wooden panelling in the first image, which was corrected for publication in *The London of Jack the Ripper Then and Now* but is here retained. The flaw was on the original negative and not the photographic print. In the second image, a loose and cut electrical cable hangs by the original door into the shop occupied by Harriet Hardiman in 1888. The third image was taken from the side of the staircase looking into the backyard. Another pipe, leading into the back room, is visible on the top right. This image makes it clear that the building had fallen into near dereliction by the 1960s, yet for most of the rest of the decade it was still in residential use. Newer cracks in the paving of the backyard, and an accumulation of junk, suggest that this series of images was taken at a different time to those taken in the backyard itself. This means Whitby visited the building, and gained access, on at least three occasions and thus infers that he had a rapport with the residents. The final image was taken looking back down the corridor to the front of the building, with the front door closed. Here, Whitby used a flash which has bleached out the right hand side of the image. It is possible to note the paving on the floor and the door leading into the back room on the left. It also shows it was impossible to walk from the front to the back of the building without turning past the staircase.

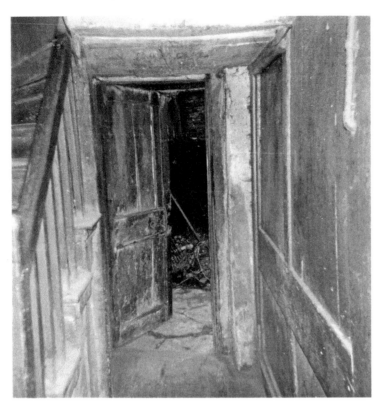

(Courtesy Margaret Whitby-Green)

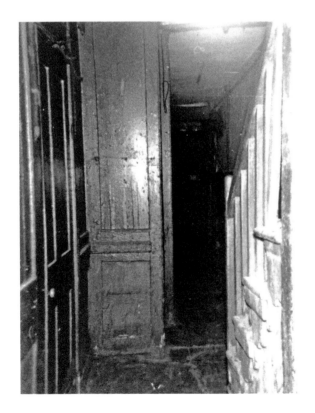

(Courtesy Margaret Whitby-Green)

ENVELOPE 5: 'Mitre Square 4 Views. 2 from where the body was found. The Old houses where the body was found were demolished some time ago.'

(Courtesy Margaret Whitby-Green)

(Kodak Velox) The first of these images was taken on a different day to the others. The differences in the displays in the flower boxes and the car in the corner confirm this. The rest of the group were, however, taken at the same time as is evidenced by the flowers and dustbins. This photograph shows the entrance to Mitre Square from Mitre Street, the irregularities in the uniformity of the pavements all too apparent. These have all changed today.

(Courtesy Margaret Whitby-Green)

(Totally blank, but probably Kodak Velox) Looking towards St James's Passage from the colloquially named 'Ripper's Corner'. Ghosts of the lettering on the old Kearley & Tonge building, dating from before the murders, are still visible on the wall. Kearley & Tonge later became International Stores who, in turn, are now better known as Somerfield. It appears here that the alleyway was further into the corner of the Square than today, but this is simply because the buildings on the eastern side extended further in than the modern wall. Priory House, dating from 1980 and visible in the 2009 image, has – at the time of writing – been empty for some years. It will most likely be demolished.

(Courtesy Margaret Whitby-Green)

(Kodak Velox) Looking up Church Passage from 'Ripper's Corner'. On the pilaster buttress right of the white doorway, you can see the blue plaque informing the reader that Mitre Square stands on the site of the Priory of the Holy Trinity. It is still on show to this day. Modern constructions, presumably in Middlesex Street, are just visible in the distance on the 1961 shot. The overpass in the top right corner was added to the Kearley & Tonge buildings in the middle of the twentieth century.

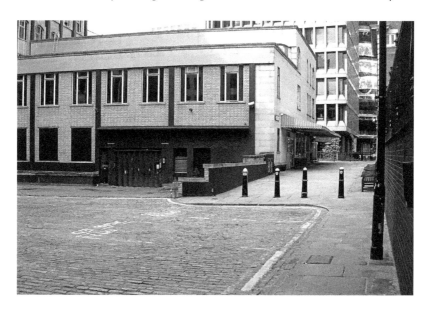

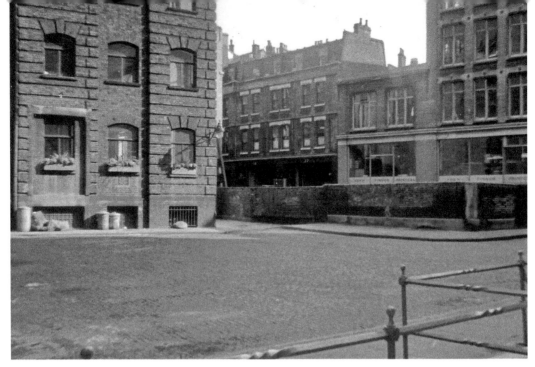

(Kodak Velox) Looking towards 'Ripper's Corner' from St James's Passage. None of these buildings, including those in Mitre Street beyond, survive. The spot where Catherine Eddowes died on 30th September 1888 is just where the low brick wall with the white band terminates. The buildings in this corner were demolished in the 1940s and the remaining walls were shortened. Prior to this demolition, the pavement here curved to the left to sweep around to the pavement with the dustbins but, by 1961, we see it has been changed. Likewise, a high wooden fence and gateway at the spot was removed. The lamp affixed to the building in the centre of the picture was added after the murder. By 2009, the corner had changed again, with nothing original remaining. Even the setts in the Square have been re-laid and may include only a small fraction of the original ones. The buildings to the left have been replaced with the playground of the Sir John Cass Foundation School. It was present at the time of the murders, although the current main building is Edwardian.

(Courtesy Margaret Whitby-Green)

34

ENVELOPE 6: 'Part of SPital Square. 3 views. I am afraid there's not much left of the place, less than a dozen houses. as you can see, the rest is taken up by a school and the market buildings.'

(Kodak Velox) The houses along the eastern side of Spital Square. This set of three were clearly taken at the same time because of the position of the single car in all the photographs. It is unknown why Whitby considered Spital Square to be important enough to warrant three photographs. Its sole connection to the Ripper case lies in the fact that the police surgeon, George Bagster Phillips, lived at 2 Spital Square, but this was demolished in 1929. Although the porch of the second building down has been recycled, the frontages there today are not the same ones visible in the 1961 photographs.

(Courtesy Margaret Whitby-Green)

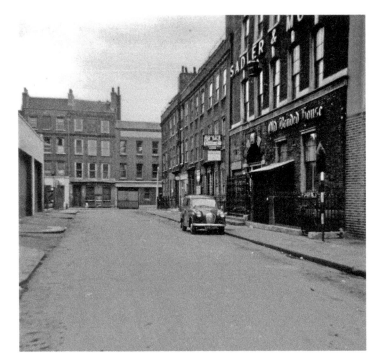

(Courtesy Margaret Whitby-Green)

(Kodak Velox) Looking north towards Folgate Street. As the buildings in the middle distance have remained unchanged, this location is easy to identify although the buildings down the main body of Spital Square have all gone.

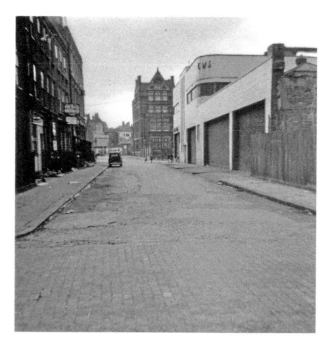

(*Courtesy Margaret Whitby-Green*)

(Kodak Velox) Looking south from Folgate Street towards Spitalfields Market, in the same position as the first image. The building on the right is recognisable for it is around here that the closing sequence of the ignored evangelist in the famed travelogue *The London Nobody Knows* was filmed in 1967.

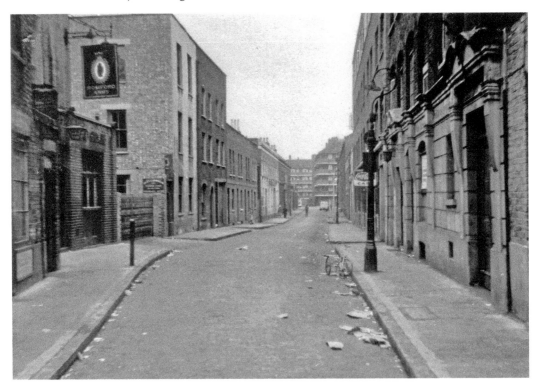

(Courtesy Margaret Whitby-Green)

(Kodak Velox) Again, a street with only the most tenuous of connections to the Whitechapel Murders and an unusual choice for Whitby's attention. The near part of the street has remained unaltered, though greater redevelopment has occurred further to the east. The difference in the pictures is marked by the greater human presence and the ubiquitous road works. Even today, you will see very little traffic moving on this part of Heneage Street. Note the child's tricycle by the street lamp on the right.

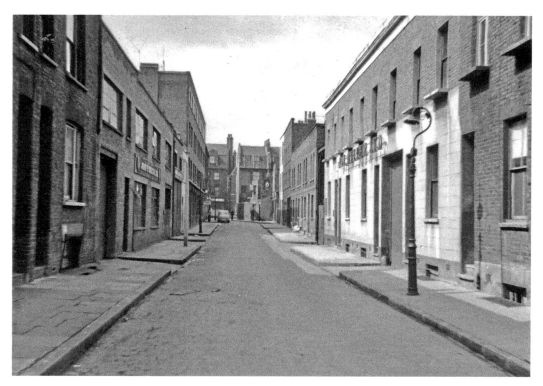

(Courtesy Margaret Whitby-Green)

(Kodak Velox) From the other end of Heneage Street, looking west. This photograph was almost definitely taken on a different day to the preceding one. The Kodak backstamp on the paper is far fainter, the image is 3mm shorter in width and the toning of the paper is different. Besides this, everything in the street has changed. Cars have moved and there is very little rubbish on the road. This second image was taken in the later afternoon. Most of the buildings in the foreground have gone but the spot is still determinable because of the vehicle entrance into the building on the left.

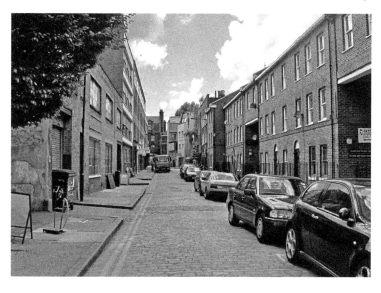

ENVELOPE 8: 'Bucks Row was Durward ST. 2 Views from where the body was found.'

(Courtesy Margaret Whitby-Green)

(Kodak Velox) Incorrect juxtaposition of the past and present street name aside, this is a most unusual pair of photographs because Whitby does not appear to have taken an image of the actual murder spot but has instead opted to take photographs looking west and east whilst standing on it. It would not have been difficult for him to find the spot of the murder of Mary Ann Nichols on 31 August 1888 as both Leonard Matters and William Stewart had clearly marked them in photographic reproductions in their books from 1928 and 1938. It is possible that Whitby did, in fact, photograph the relevant gateway but the image has been lost. This picture shows the tall wall over the railway line on the left, still extant, and part of the old Board School beyond. The warehouses seen here on the northern side have long gone, making Durward Street a more open place. Small flaws on the negative indicate this may be a slightly later reprint.

(Totally blank, but probably Kodak Velox) Looking east from the murder spot. The warehouses of Brown & Eagle Ltd occupy most of the northern side. This image has slightly different toning to the preceding one, so it may have been taken at a different time or the first image is, as stated, a reprint. Most interesting here is the fencing on the right. This dates the image to the interim between the destruction of New Cottage in World War Two and the construction of a garage on this spot. In the 1950s, a motor repair business lay behind. This may well be the only image known to exist from that period.

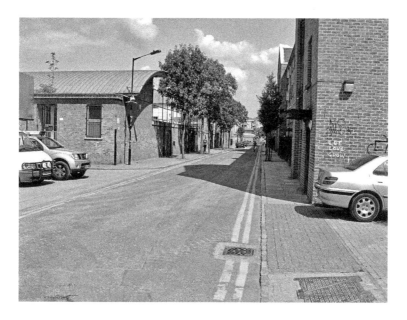

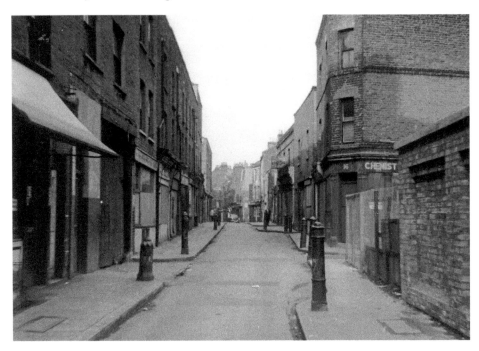

(Courtesy Margaret Whitby-Green)

(Kodak Velox) A fascinating image, looking east from the junction with Brick Lane and Osborn Street. Yet again, it is unknown why Whitby chose to photograph this spot when, if he had turned around, he could have taken a picture of the site of the fatal attack upon Emma Smith on 3 April 1888. Whitby erroneously missed the 'e' off the end of 'Montague'. The Whitechapel Mortuary had lain a short distance off the far point of this image. Research on old maps suggested the correct location of this picture, which was confirmed by the presence of the squat brick building on the right – the only thing visible here that survives today. In the 1990s, the street was entirely ripped down and widened considerably. The location of the buildings on the left is now in the middle of the road.

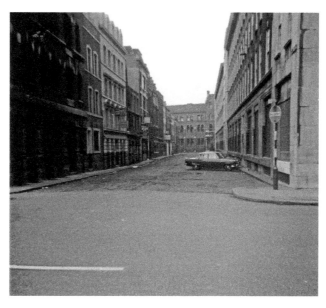

(Courtesy Margaret Whitby-Green)

(Kodak Velox) Both these images were almost certainly taken on the same day as the corridor in Hanbury Street and those of Spital Square; all the locations are close together and all these are the only 3.5" square photographs in the collection. It is not surprising that Whitby titled these envelopes as 'Dorset Street' (the site of the infamous murder of Mary Jane Kelly on 9 November 1888), although it was renamed Duval Street in 1904. The buildings on the right, belonging to the London Fruit Exchange, were constructed in 1929 following the demolition of the original buildings. The buildings on the left came down two years after this photograph was taken. The second building down the street had been the location of a fatal gangland shooting the previous year. The cars on the left are close to the spot where the alley of Miller's Court once ran.

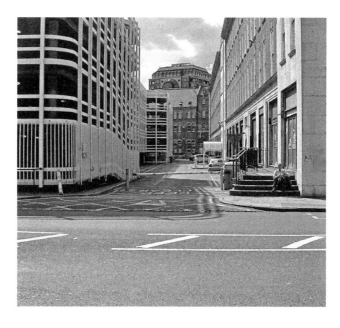

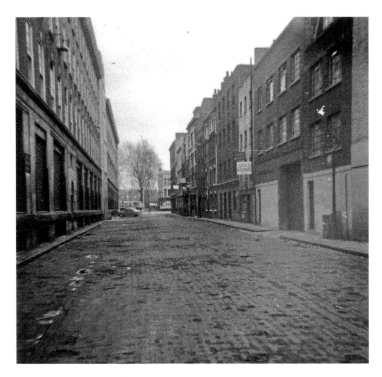

(Courtesy Margaret Whitby-Green)

(Kodak Velox) Again, small flaws on the negative suggest this may be a later reprint but it was clearly taken at the same time as the image shot from the other direction.

The Dutfield's Yard Photograph

The internet auction site eBay is a curious place. A seller may give a detailed description of an item and, because the very nature of transactions on eBay are usually long-distance, when the item arrives it is usually as expected but can also be considerably better or considerably worse. It is the nature of the beast. I have been buying and selling copious amounts of goods on eBay (at the time of writing about 10,000 transactions) since early 2004 and have, through hours of painstaking scanning of daily listings, managed to acquire some very unusual items related to criminology over the years; the handcuffs in which the first railway murderer Franz Müller was arrested, the original family photographs of John George Haigh (the acid bath murderer), an invoice signed by Dr Crippen and typed by Ethel Le Neve just before they fled the country and the final written statement from 1679 of Lawrence Hill, the day before he was executed at Tyburn for the murder of Sir Edmund Berry Godfrey. I've also managed to acquire many rare books on Jack the Ripper by this method, as well as documents and postcards related to the East End of that time. However, in November 2007 I noted an eBay auction that was to become heralded by some as possibly the most important photographic discovery in the case for quarter of a century.

Larry Lingle was a child of the depressed 1930s in the Southern States of America. He lives out his retirement in Houston, Texas, having graduated with a History Masters and later running a gay bookshop. Today, he supplements a meagre income by selling original and unique photographs on eBay under the name 'linglelobo', an occupation he has been undertaking for over a decade. Most of his sales are images with an historic connection; either press syndicated professional shots from the first half of the twentieth century or vast amounts of early carte de visites from the time of the American Civil War. He also buys old photograph albums at auctions and sells the images within individually.

Thus it was that, at 2:09am GMT on 13 November 2007, Larry listed an auction with the banner heading '1890s PHOT SCENE OF INFAMOUS WHITECHAPEL MURDERS LONDON'. The auction listing read as follows : 'Vintage, original silver gelatine photograph, 3.5" x 4.5", of a street in the Whitechapel area of London in the 1890s, scene of the infamous series of murders of prostitutes, some

Larry Lingle at home with his bassets *(Courtesy Larry Lingle)*

of which at least were connected with Jack the Ripper. In very good condition.' The image alongside it was small and not instantly recognisable as anywhere well-known in the Ripper case. Buildings were visible in the background and there were many people crowding around the camera, leaving a space in the middle to look down the street or alley in which they were standing. It just appeared to be yet another unidentifiable East End location.

Nevertheless, my interest piqued, I placed a single bid on the photograph at the opening price of $4.95 (the equivalent of £2.44 in 2007). When it closed overnight on the 20 November I had been the only bidder and thus became the owner of whatever the image was. I paid the nominal shipping sum and within two weeks a hardback envelope had arrived from Larry.

The picture within had clearly been formerly affixed to a photograph album because of the small amounts of rough, cream paper still adherent to the reverse. When seeing it for the first time, something instantly looked familiar but I could not equate it with the rest of the image. Something about the arrangement of the buildings in the background made me sure I had seen a location very much like it before. It looked like drawings I had seen from the period of Dutfield's Yard, running at the side of 40 Berner Street – the site of the murder of Elizabeth Stride (presumably by Jack the Ripper) at approximately 1 am on 30 September 1888. At this point, however, I just thought it a coincidence and had decided that the sale of the image linking it to the Whitechapel Murders was nothing more than a sales pitch (some sellers on eBay put Jack the Ripper in the banner heading simply because the item they're selling dates from 1888 and may not even have any connection to London, let alone the case). There were several reasons for doubt at this stage.

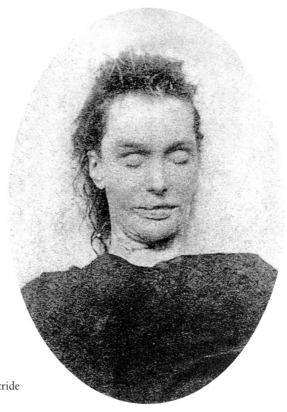

Mortuary photograph of Elizabeth Stride
(Courtesy Stewart P. Evans)

Some things did not match some of the line drawings from the time of the murders, reproduced in the likes of the gratuitous *Illustrated Police News* and *The Penny Illustrated Paper*. The staircase at the rear of the picture was not in the same place in which it was sometimes seen in illustrations. There was only one door on the right hand side of the buildings stretching away from the photographer, yet most of the sketches showed a series of doorways. Most oddly of all, this alleyway appeared to be far longer than one would expect Dutfield's Yard to be.

Dating the Image

I could not really get a handle on the exact date of the photograph, so I contacted Dennis Weidner who is the webmaster of a US-based site dealing with boys' historical clothing, as several boys were in the image and one was facing full-length into the camera. Dennis's reply indicated that he felt the image dated to the late 1890s because of the mix of long and short trousers worn by the boys in the photograph. His knowledge on clothing styles is such that he knew shorter length trousers worn with stockings became fashionable in the UK during the final years of Victoria's reign. However, he pointed out that one boy wearing a cap on the

right, standing a few people down from the camera and looking away into the yard, was wearing long trousers. A much closer inspection of the image, however, revealed that this was actually a grown man (bearded!) with knarled hands that just happened to be quite short and was wearing a style of cap one would expect to see more often on a child. Thus, I concluded that no boys in the image were wearing full-length trousers. Likewise, the younger girls in the image are identifiable by their calf-length skirts, a fashion deemed unthinkable for adult women in such an age of prudery. Finally, Dennis suggested that amateur exterior photography was quite rare before the 1890s, although it was known to exist if the photographer was fairly affluent. It is likely that the matter would have rested at that point had I not continued corresponding with Larry Lingle.

Larry informed me that he still had the majority of the album from which the photograph had been extracted. Three photographs (one of an Italian street urchin, one of the site of the Guillotine in Paris and one of the actor Anton Lang) had already been sold to other buyers and it is now very unlikely these will ever be found. However, most of the album was still in his possession. Some of the pages had been torn out, awaiting auction listing, and these were no longer in any order.

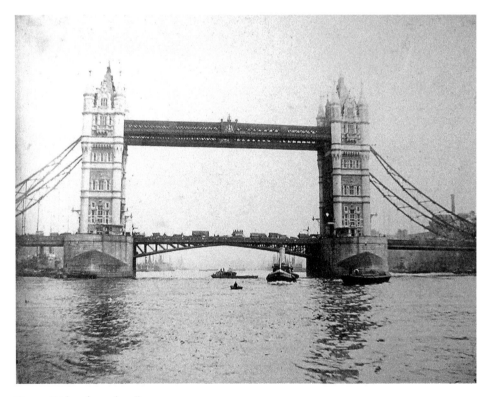

Tower Bridge, from the album

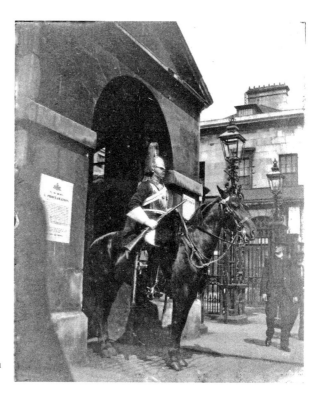

Her Majesty's Horseguard, from
the album

Several photos had been removed from their backing in the album. I arranged to
purchase the rest of the album from Larry for a respectable but sensible sum and
this was delivered in late December 2007.

Two things within the album instantly informed me that the Dutfield's Yard image
was taken between 1894 and 1901. Firstly, there is a photograph of Tower Bridge
in use. The bridge was not opened until 1894. Secondly, there is a photograph of
a Horseguard, identified by military historian Peter McClelland as being from
The Royal Horseguards and 1st Dragoons (now better known as the Household
Cavalry Regiment Mounted). Peter pointed out that the presence of a rifle would
date this to the time of the Boer War and the type of sword scabbard just visible
to the rider's left was replaced in 1902. More telling was the fact that the owner
of the photograph album had, in antiquity, written 'Her Majesty's Horseguards' on
the page, clearly dating the image to no later than 1901 with the death of Queen
Victoria and the Royal line then continuing with King Edward VII. This album page
has been lost, but Larry had written the wording on the back of the photograph
pending auction listing.

All this detective work came to fruition when, much later in the album, I found
the (now empty) page that had once held the missing photograph of the actor
Anton Lang. In very faded ink at the bottom of the page was the words 'Anton

Anton Lang

Lang, Christus of Oberammergau Passion Play 1900'. Lang, a potter, was almost certainly the best-known of all the many actors who have played the role of Christ at the world-famous German event, consisting of a cast of local people, over the many years it has taken place. He played the role several times in the early 20th century in 1900, 1910 and 1922. Thus the date of 1900 was virtually confirmed.

The Album

The album containing the photographs is now extremely fragile. It measures 8" x 6.5" x 1.25". The cover is very brittle and is made of board, backed with a white cotton weave and fronted with a dark brown knobbled and textured veneer. The spine is missing but traces of the same veneer still exist where it once lay. It is held together with three round-headed pins on the front face of the album. The back has warped and appears to have some water damage. A label is affixed to the bottom left corner of the inside back page, reading 'MFD BY THE HEINN SPECIALITY

The front of the photograph album

The Heinn label in the album

CO. MILWAUKEE, WIS. BADGER ALBUMS', with the number '642' stamped in red ink in a small cartouche beneath. The whole album gives off a curious strong scent of sherbet.

The paper inside, cream but yellowing with age, is dry, thick and textured, similar to the paper one would find in a scrapbook today. The binding is still tight in spite of the damage to the album. It consisted of 82 pages and only the last 12 pages are unused. The last nine photographs clearly date to a later period than the rest of the album, as they are all postcard-style, on card with white borders. The last nine images are also American in origin, whereas all the other images (save the first in the album) were taken throughout Europe.

Reconstruction of the album was a slow process. Thankfully, nearly all the images from the European tour had explanatory notes (sometimes extensive) on the pages if the photograph had been removed. All matched with tears on the paper or with an explanation of the subject. Once these had been grouped and reglued, the loose pages were replaced in their original locations. This could only be achieved by comparison of the tears close to the binding and on the pages themselves. Thankfully, all of them had slight deviations which made accurate matching easier.

Once this process was completed, it was discovered that only one sheet of the album was missing. That sheet was the page from which the Horseguards image had come. There was no sign of the image that would have once been affixed to the other side of the sheet and this initially gave rise to some curiosity. The preceding images had come from the photographer's time in London, and the next complete sheet continued in Ireland. Was the missing image a London photograph and, if so, did it have a connection to the Whitechapel Murders? Such possibilities were brought to an end when, in early 2009, Larry discovered the missing image and forwarded it to me – a street scene in Dublin.

This made a total of 58 remaining photographs of the European section of the album. The photographs were all centred on their pages and appeared to largely (but not exclusively) be in some kind of order, generally grouped by country – and there were many countries covered. Most of the images had taken on a strange yellow-purple-brown tint over the years. Silver gelatine prints are known to be unstable and liable to alter their hues, sometimes fading completely. Indeed, several of the prints in the album had faded a great deal, whereas others retained their full tonal range in spite of the general colour shift. Thankfully, the important photograph falls into the second category.

The photographs were on thin photographic paper and all appeared to have been carefully cut by hand, mostly being of slightly different sizes. Initially, I had suspected that the photographs had previously been kept in a different album with apertures for viewing the images as many of the photos had thin lines of the print flaked off a little way from the edges. I later discovered that each section of damage corresponded exactly with the placing of the print on the page next to it.

Detail of damage
to the Dutfield's
Yard photograph

This is because the photographs were originally glued on their backs right up to the edges and small amounts of adhesive had clearly seeped over the rear face of the photographs and touched the front of whatever was placed on top of, or below, it. Sadly, this also affected the main photograph in the series and it took a great deal of work with editing software to repair these faults. The tiny flakes pulled from the image in antiquity are still affixed to a photograph of St James's Park on the opposite page. Unfortunately, the Dutfield's Yard image appears to have suffered more damage in this way than any other photograph in the album.

It is generally agreed by all who have seen the photographs that they were taken with an early Box Brownie, with a fixed length lens. All the images are clear and sharp except when subjects are very close (two metres or less) from the camera.

Authentication of the Image

Initially, I informed a small circle of Ripper and East End historians known to me personally about the possible discovery. The work of some, most notably my co-author on *The London of Jack the Ripper Then and Now,* Robert Clack, and Jake Luukanen was to prove extremely useful.

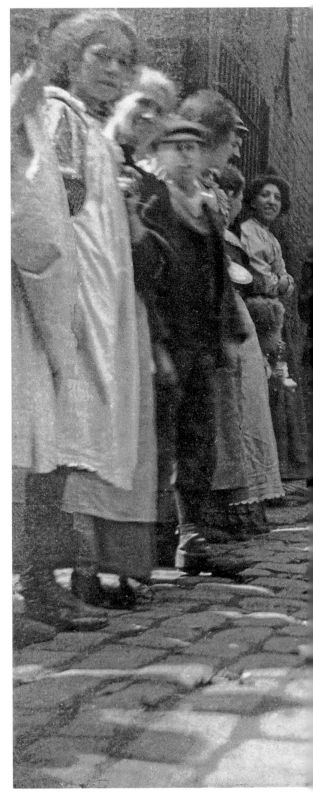

Dutfield's Yard, circa 11:30 am, late June
– early July 1900 *(Photographic restoration
2008-9 © Philip Hutchinson)*

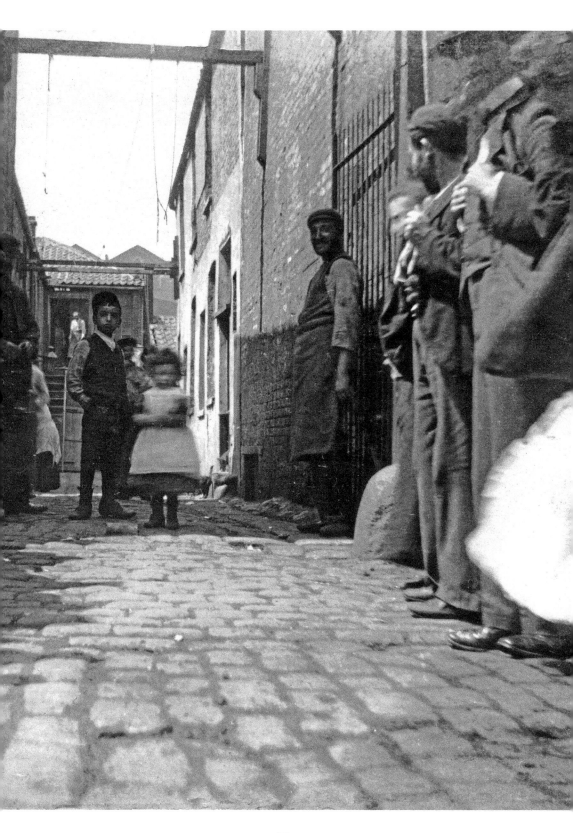

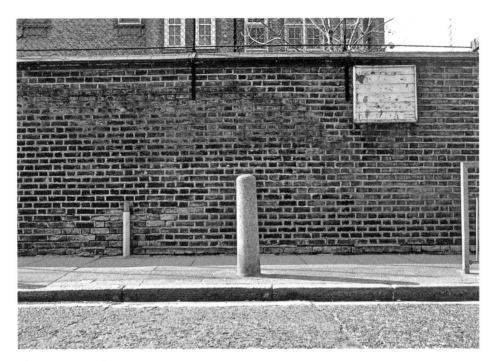

The same spot today

Firstly, I had to work out why this alleyway looked a great deal longer than we know Dutfield's Yard to have been. It quickly became obvious. The individuals were not lining the alleyway at all, but most of them were standing at the entrance and well into the road of Berner Street itself. This instantly made sense because of the change in the direction of the setts on the floor and, most tellingly, shadows cast by the first half-dozen people on the left. If they had been standing inside the yard, backs against the wall, these shadows would not have been cast. Indeed, a solid shadow runs right across the yard just beyond here. Thus, three people were standing where the pavement breaks to allow vehicular access and three actually in the main road. The photographer would have been closer to the other side of Berner Street than the side being photographed. At the bottom left, there are two further shadows of people not seen in the photograph, forever immortalised as no more than silhouettes. Researcher Neil Bell has estimated from these shadows that the photograph was taken at approximately 11:30 am. It is likely to have been sometime close to the middle of the year because, although the males are largely suited as was the fashion, the girls and women are not generally wearing coats, shawls or jackets.

Having established the date as 1900, the next step was to confirm with other researchers that this was indeed Dutfield's Yard. Firstly, there was the issue of the

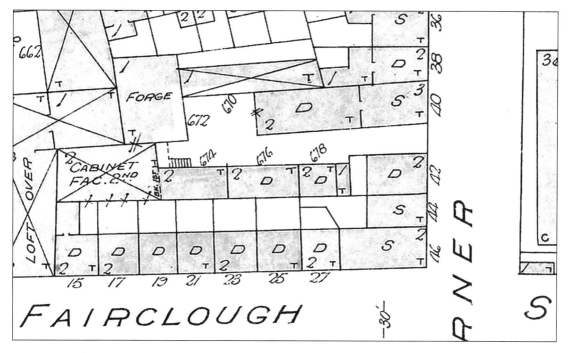

Detail from the Goad's fire insurance map, May 1899 *(Courtesy Robert Clack)*

single doorway on the right hand side, when some illustrations show a series of doors. This was easily explained away as artistic errors. It is known from maps and descriptions that there was but one doorway into the building on this side. Illustrations, later erroneously repeated, marked the numerous windows as being doorways. It always was, of course, extremely unlikely that there would be a whole series of irrelevant doors right next to each other down the length of the building. Next, there was the issue of the staircase and doorway at the end of the yard, placed next to the left-hand corner. Whenever they were shown in illustrations, they had been on the right-hand side. Inspection of Goad's fire insurance maps quickly confirmed that the illustrations were all wrong, and the staircase and doorway had always been where they appeared in the photo. Finally, it was understood that at the time of the Stride murder, the alleyway had been largely unpaved and was muddy. Indeed, one side of Stride's body was found to have mud on it where she had been dropped in a gutter. Why do we see it paved here? Well, the meeting place of the International Workers' Educational Club (the building at the rear with the many windows) was deemed unsafe by the Buildings Inspector in 1892 and it is probable that the shoring of the building (spanning the top of the photograph) and the paving date from this time. The three lengths of rope hanging from the forward beam, terminating at least 10' above the ground, are less easy to explain.

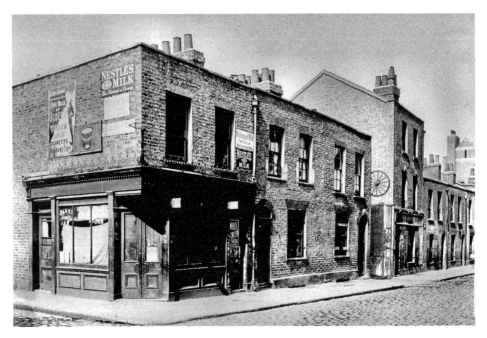

Berner Street, showing the entrance to Dutfield's Yard, 7 April 1909

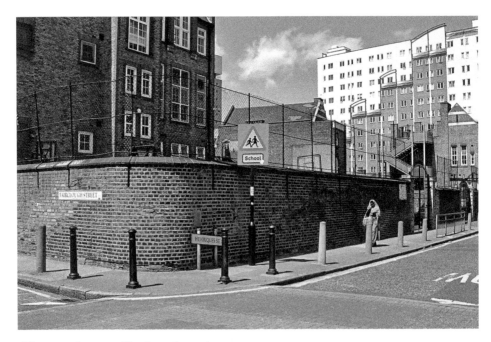

The same view, now Henriques Street, in 2009

So much for having to account for the supposed inconsistencies; now for further confirmation of the location. Researcher Tom Wescott undertook an exhaustive study of Berner Street which was published in *Ripper Notes* in 2007.

According to his work, the entrance onto Berner Street was 9' 2" wide. Although there were wooden doors at the time of the murder, by the time the famous image of Berner Street was taken on 7 April 1909 (shortly before demolition) they had been replaced by metal gates. The gates visible in the famous Berner Street photograph of 1909 image seem to be a perfect match for the gates shown in 1900. Although the lower diagonal strut on the right gate appears to run in a different direction to the gate in the 1909 photograph, the later image actually shows the left gate. Likewise, the rounded stone at the entrance – designed to prevent carriages hitting the wall as they came into the yard – is evident. In front of the two small children standing in the middle of the yard there is a squat metal stopper, maybe about 6' long. This would have been set in the ground to prevent the gates from swinging open outwards.

Detail of the Dutfield's Yard gates, 7 April 1909

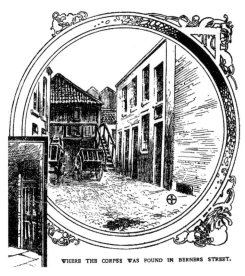

WHERE THE CORPSE WAS FOUND IN BERNERS STREET.

Above left: Inside Dutfield's Yard from *The Weekly Dispatch*, 7 October 1888 *(Courtesy Robert Clack)*

Above right: Dutfield's Yard from *Famous Crimes Past & Present*, 1903 *(Courtesy Thomas Schachner)*

Left: Dutfield's Yard from *The Pictorial World*, 6 October 1888 *(Courtesy Robert Clack)*

Down the yard on the left is a wall-mounted lamp, matching contemporary descriptions. Just before it, a thin shaft of light is visible, breaking the shadow cast by 42 Berner Street. This was a known gap between the main building and those behind it, as is recorded in all descriptions and plans. Beyond that, the alley widens and there can clearly be seen a row of smaller buildings with at least one chimney on show beyond. This is a set of three cottages, converted from one older building, just after a lavatory at the back of 42 Berner Street.

Just beyond the smiling man standing at the end of the gateway on the right, we see a rough gutter. Some stones run up against the wall and a pair of setts are matched running down towards the steps beyond. This spot – where no one is standing, for an obvious reason – is where Elizabeth Stride was killed. At the end of the gutter is a grille set into the lower wall of 40 Berner Street. This gave light and ventilation to the basement room and is clearly seen in all illustrations from the period. Straight after this is the door into the club building. What appears to be a partition two-thirds of the way up is actually where an overhead fanlight was situated, again known from all the descriptions from the time. Beyond this is a set of four windows of irregular height. As mentioned, these are sometimes incorrectly illustrated as doorways (such as in the famous Harold Furniss illustration from *Famous Crimes Past & Present*, published in 1903) and the chances are that this was an assumption made from an illustration published in *The Pictorial World* of 6 October 1888 where Louis Diemschutz, who is historically credited with discovery of the body, is covering the bottom of the windows beyond. In fact, this earlier illustration clearly shows the windows along the side of the building matching almost exactly the windows evident in the 1900 photograph.

At the back of the yard, we see a taller building to the left and a single-storey structure to its right, clearly leading out of shot and indicating that the yard turns to its right beyond the club building, something that is definitely known to have been the case at Dutfield's Yard. These two buildings are instantly recognisable from any illustration of the yard. This taller building originally housed Walter Hindley & Co, sack manufacturers, and it is presumed that the smaller building (at some stage a forge) housed Arthur Dutfield, the wheelwright who had given the yard its name (the cartwheel on the 1909 image relates to this business). There appears to be a small gap between the tiles on the left of this lower building and the side of the structure. Beyond this, not visible on the image, were stables.

There is some confusion as to the roles played by these buildings in contemporary descriptions. Although the stables are not in dispute, Jake Luukanen discovered that the Goad's maps had some discrepancies when it came to naming the industries undertaken. They mark the taller building as a cabinet manufactory (and this would certainly seem to fit with the aprons worn by the men standing in its doorway) and the single-storey building as being the sack business (or, in one version, the forge).

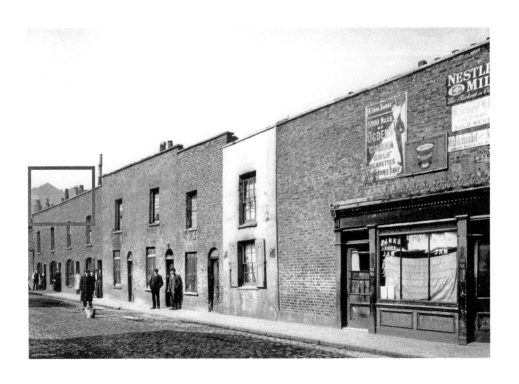

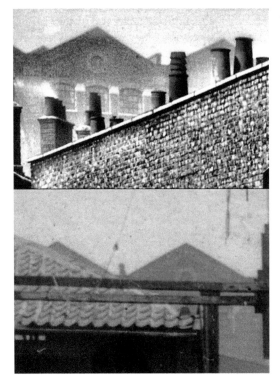

Above: Fairclough Street, with the warehouse roof highlighted, 7 April 1909 *(Courtesy Robert Clack)*

Left: Comparison of the warehouse roof from the 1909 and 1900 photographs

62

Jake has concluded that the sacking company probably moved into the lower building when Dutfield relocated to Upper Smithfield.

On the 1894 Ordnance Survey map, the staircase is indeed placed on the right of the building, as it is shown in some illustrations but not on the Goad's map or the 1900 photograph. It is, of course, perfectly possible that the stairs were not firmly fixed and could be moved at will.

However, the clincher came as the result of some remarkable work by Robert Clack. In the middle distance of the background, some way off, can be seen two matching gables of a building. The gable on the right has a circular window near its apex, and the gables are separated by what appears to be an irrelevant course of bricks or stone between them. When the photograph was taken of Berner Street in 1909, the photographer also took (from the same position) a lesser-known image of Fairclough Street simply by turning the camera to his left.

The building visible in the background is the Commercial Road Goods Depot and Warehouses belonging to the London, Tilbury and Southend Railway Goods Station. The side facing the photographer was on Gowers Walk. It matches perfectly, in every way, with the building visible in the distance on the 1900 shot. There could now be no doubt whatsoever that the image was indeed of Dutfield's Yard.

The Album Contents

Most of the photographs in the album were well-composed and covered a huge part of Europe. The owner had written some interesting anecdotes relating to the events around the time the pictures were taken. The first image in the album was badly damaged and almost faded beyond recognition. It was titled 'Dewey Arch, New York'. This was yet further confirmation on dating the album. The Dewey Arch stood at Madison Square as a triumphal arch built for a parade celebrating the return of Admiral George Dewey, following a military victory at the Battle of Manila Bay in 1898. It was designed by the architect Charles R Lamb and quickly constructed in the summer of 1899, the parade being held on 30 September that year (by coincidence, the anniversary of the murder of Elizabeth Stride). After the parade, the arch quickly deteriorated and was thus demolished in 1901.

The following two images were taken in Stratford-on-Avon. The seven after these were all taken in London, with a further Stratford-on-Avon picture in the middle. The very first of the London images was that of Dutfield's Yard. This was followed by ones of St James' Park and Tower Bridge. The next is of the Statue of Peace in Smithfield, which the owner has noted as being the 'scene of burning of Christian Martyrs' which, according to the historian Martin Fido, makes it likely the photographer was a Protestant because of the phrasing used. The statue was part of a drinking fountain erected by the Metropolitan Drinking Fountain Society in 1870 and still exists to this day.

Dewey Arch, from the album

A colour postcard view of Dewey Arch, also from 1900

Detail of St James's Park, from the album

Detail of the Peace Fountain in Smithfield, from the album

The Tower of London, from the album

After the photograph of Anne Hathaway's Cottage, put in the wrong order, is a faded image of the Tower of London with some soldiers being drilled in front of it. The London set finishes with a shot of the Albert Memorial and the Horseguard.

The photographs then move on to Ireland and in the second image we see the photographer of the other images sitting in a pony-trap with an Irish market-woman and it becomes clear that the owner of the photographs is a woman. She appears in several other photographs, always wearing fairly elaborate headwear with small brims. A few images further on is a picture of the ruins of Ross Castle at Killarney. Underneath this, the photographer has written 'While taking this photo my party left me behind in Killarney wilderness. Rescued later by Cook jaunting car'. This final sentence provided the key to some fascinating later discoveries.

After the Irish images, there is one of Monte Carlo, three of France, one of Belgium and an ethnic photo of a Dutch family dressed in bizarre clothing.

The next page holds a damaged but awe-inspiring photograph of the picturesque glacier Mer de Glace at Chamonix. The photographer writes underneath 'Here I crossed without a guide'. It is impossible to contemplate that she actually means she crossed the glacier alone and unaided.

Detail of the photographer with an Irish market-woman, from the album

Ross Castle, from the album

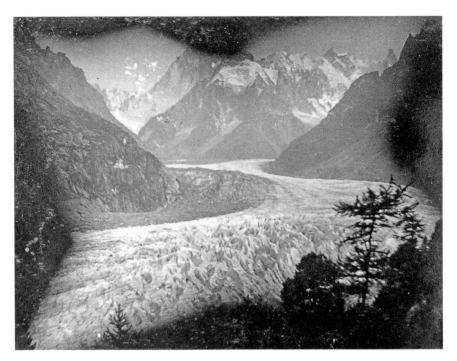

Mer de Glace, from the album

Hotel Deutsches Haus, Bingen, from the album

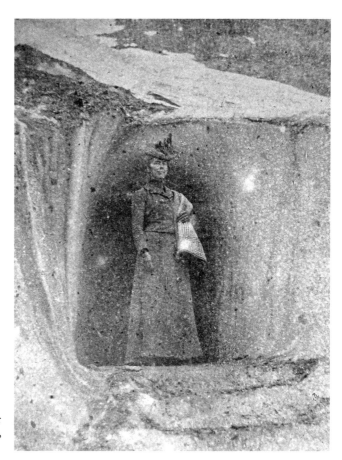

Detail of the photographer
in an ice cave, Mer de Glace,
from the album

The album then moves on to Germany and under a picture of the Hotel
Deutsches Haus in Bingen (looking very similar to one standing today, albeit with
many alterations) she recalls 'Here I slept with a feather bed over me and a bootjack
under my bed'.

After one image of Geneva, the bulk of the photographs are from the main
destination of the trip – Italy. Several photographs were taken in Venice, others in
Rome, Florence, Pisa, Genoa, Bordighera, Pompeii and Naples. Amongst the Rome
images are photos of two named women (possibly travelling companions) and a
clear image of the photographer herself – sadly, with her eyes closed. The Europe
images conclude with another shot from Holland of a dog pulling a cart and finally
of the photographer standing in an ice cave at Mer de Glace.

The rest of the album consists of the nine later images taken in the US. An old
woman (the photographer in her later years?) in a white dress sits, surrounded by
flowers, on the veranda of a small wooden outbuilding in the first. The second is
of a middle-class clapboard house. There are several rustic photographs of people

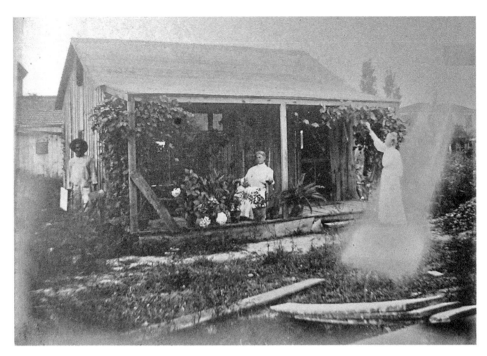

Later American photograph, from the album

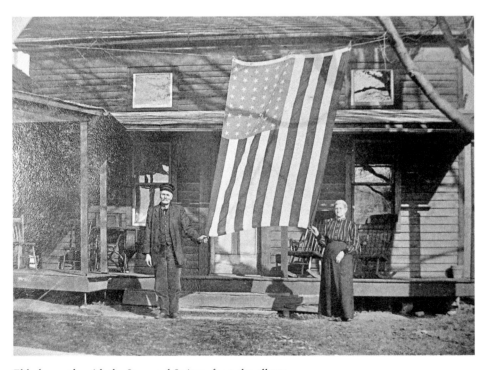

Elderly couple with the Stars and Stripes, from the album

chopping wood and fishing, as well as photographs taken inside a house of a family round a table, a painting of a distinguished-looking gentleman and another of a well-dressed little girl standing next to an easel which holds a painting of a small child. Another painting is visible in the background.

The final shot in the album is of an elderly couple outside a different clapboard house. The old woman may well be the same one in the white dress from the earlier image. They flank a huge Stars and Stripes flag, hung from the roof. Dee Anna Grimsrud of the Wisconsin Historical Society inspected the later photos and had to conclude that they could be of almost anywhere. However, the final image did provide some interesting information. She noticed that the flag not only appeared to be brand new, but that it had 48 stars on it. The probability is that the photograph was taken when Arizona became the 48th State of America on 14 February 1912, a dozen years after the European trip. This could suggest the photographer came from Arizona, but it is nothing more than a possibility.

Ellen Engseth of the Wisconsin Historical Society provided me with information on the Heinn label at the back of the album. Heinn was a large Milwaukee-based company dealing in stationery and they are credited with creating the loose-leaf system of filing. Between 1896 and 1977, they were extremely prolific throughout the US and not just in Wisconsin. The red stamp of the number '642' probably relates only to the type of album being sold. The company is now owned by Majestic Industries, but numerous e-mails to them over a long period of time elicited no reply.

The European Vacation

In the same e-mail where she noted the Arizona connection, Dee Anna Grimsrud asked me if I had contacted Cook's Tours to see if their business records went back to 1900. I had actually not seriously considered a planned package deal extended break to Europe from so early a date, though I knew that Thomas Cook did run excursions, and had assumed it to have been an independent journey the photographer had arranged herself. The mention of Thomas Cook did bring to mind the comment in the album from Ross Castle, when the photographer mentioned she was collected by a Cook's jaunting car.

Unsurprisingly, I had expected a Cook's jaunting car to have been a charabanc of some description. Martin Fido subsequently pointed out, however, that a jaunting car in Ireland at that time was not a powered vehicle but a tiny pony and trap, on which the passengers would sit along the sides. There was always the possibility, of course, that the jaunting car had just been in the vicinity and came to the photographer's assistance but seeing the name of Cook now mentioned twice, I thought it worthy of direct investigation.

I sent an e-mail to the Archive Department at Thomas Cook. Cook, a cabinet maker from Market Harborough, first held an excursion on 5 July 1841 when he

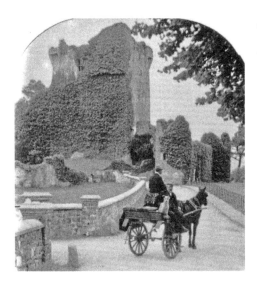

Above: A Cook's touring car in Paris, 1900

Left: An Irish jaunting car at Blarney Castle

organised a trip from Leicester to Loughborough for fellow Temperance Society members to attend a meeting by train. His first commercial venture was to Liverpool in 1845 and in 1855 he began to branch out into Europe, his business being helped by the International Exhibition in Paris. Trips to America followed in 1865. By the time of the 1900 vacation, Thomas Cook was the largest organisation of its kind in the world, with branches in many major countries.

Paul Smith runs the extensive Archive Department and his communication of 14 August 2008 was to prove extremely useful:

'Many Americans visited Europe in the late nineteenth and early twentieth centuries as part of an escorted Cook's Tour. These tours were especially popular in

A Thomas Cook advertising poster from 1900

1900, as tourists in this year were presented with the unique opportunity of visiting both the Paris Exposition (including the Olympic Games) and the Passion Play at Oberammergau. All European tours in 1900 appear to have included a few days in Paris; many of them also featured a visit to Oberammergau; but only one tour appears to have also incorporated a tour of Ireland (which you mention). This was 'Tour No. 22' and the itinerary, as listed in the pages of the American edition of *Cook's Excursionist and Tourist Advertiser* (a monthly newspaper issued by Thos Cook & Son), was as follows:

New York, Queenstown, Cork, Blarney Castle, Glengariff, Killarney, Dublin (3 days), Belfast, Giant's Causeway, Larne, Glasgow, The Trossachs, Edinburgh, Melrose, London (7 days), Paris and the Exposition (8 days), Brussels, Antwerp, The Hague, Amsterdam, Cologne, Bonn, The Rhine, Mayence, Heidelberg, Munich, Oberammergau, Lake Constance, Falls of the Rhine, Lucerne, The Rigi, Brunig Pass, Interlaken, Grindelwald, Berne, Lausanne, Fribourg, Geneva, Chamonix, Tete Noir Pass, Martigny, Brigue, Simplon Pass, Stresa, Milan, Venice, Florence, Rome (6 days), Naples, Capri, Sorrento, Pompeii, Vesuvius, Naples, New York.

The tour lasted 103 days and cost $970.

The fares included: travel tickets and hotel accommodation at first-class hotels; transportation of 250lbs of baggage on the ocean steamers and 56lbs on the railways; omnibuses between stations, piers and hotels; fees for sightseeing and carriage drives; fees to hotel servants and railway porters; and 'the services of an experienced Conductor, who will supervise the arrangements throughout'. The fares did not include: steward's fees on the ocean steamers; wines, liquors or other drink not ordinarily supplied at table d'hôte; expenses of carriages, guides or sightseeing when not ordered by the Conductor.

The tour was originally advertised as departing New York aboard the Cunard Line Steamship *Umbria* on Saturday 26 May 1900, but the April, May and June editions of *Cook's Excursionist* shows a revised departure date of Saturday 2 June 1900 and a new ship: Cunard's *Lucania*.

Details of the hotels to be used in Paris are listed in the 'Excursionist' but I am afraid no information is provided about any other hotels used on this tour. However, a 4-page list of all the hotels used by Thos Cook & Son throughout the world appears in every issue of the *Excursionist*.

This was a remarkable breakthrough, as it set in stone the times of the European vacation. We know that the tourist came from America because the first image in the series is of the short-lived Dewey Arch in New York from where, of course, the *Lucania* would sail.

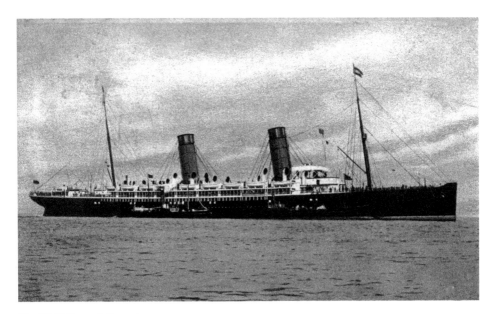

The RMS Cunard *Lucania*

The RMS Cunard *Lucania* was a steamer built in Glasgow in 1893 and made her maiden voyage on 2 September that year. She was one of the largest ships of her day, weighing 12,950 tons, 620' long and capable of holding 2,000 passengers (600 First Class, 400 Second Class and 1000 Third Class). Through the 1890s, she constantly beat speed records on the North American transatlantic route. In 1901, she became the first Cunard ship to be fitted with Marconi wireless.

First Class accommodation on board the *Lucania* was the finest money could buy. The public rooms (and state rooms on the upper deck) were heavily panelled in oak, satinwood and mahogany. The floors were thickly carpeted, the furniture heavily upholstered and velvet curtains hung over every porthole and window. The First Class smoking room held the first ever open fire on a passenger ship. The First Class dining saloon was unsurpassed, rising 10' and possessing a central well that pierced through three decks to a skylight. The ceilings were white and gold, supported by Ionic columns, and the walls were of mahogany, inlaid with ivory.

By the late 1890s she was superseded by newer liners from Germany and in 1907 she and her sister ship the *Campania* were replaced by the new Cunard liners the *Lusitania* and *Mauretania*. She made her last voyage on 7 July 1909.

However, whilst laid up at Huskisson Dock in Liverpool on 14 August 1909, she was gutted by fire, partially sank at her berth, and was sold five days later. She was broken up at Swansea, her contents being auctioned off. Indeed, items from the ship still regularly turn up on eBay to this day, mostly in the US. Film exists of passengers boarding the ship at Liverpool, taken by Mitchell and Kenyon in 1901 and held by the British Film Institute in London. The Captain for most of the Atlantic crossings at this time was Horatio McKay.

Having left the Thomas Cook party at Queenstown, the *Lucania* continued to Liverpool to begin the return journey to the US with new passengers, departing England on 16 June 1900.

The $970 cost of the trip would equate today to $25,000 or £15,000. This was not a trip taken by a woman of meagre means.

Thomas Cook used two main hotels in London for its travellers' use but it is likely that our tourist was staying at The Langham. In the early years of tourism, richer transients were lodged in private houses but it is unlikely this would have still been occurring by 1900. The Langham was opened in 1865 as Europe's first 'Grand Hotel' and is still a thriving concern situated in Portland Place, Regent Street. Many notable historic figures have been guests there such as Oscar Wilde, Henry Morton Stanley, William Gladstone, Henry Longfellow, Mark Twain, Arthur Conan Doyle, Dvorak, Somerset Maugham, The Prince of Wales (Edward VII) and Napoleon III.

Given the delay in departure of the *Lucania* from New York and the time spent in Ireland (at that time still one country) and other parts of Great Britain (largely passing undocumented in this album) then it can be safely estimated that our tourist

was in London at the very end of June and start of July 1900, but it is extremely unlikely that any precise date will become available.

What stands out is that the image of Dutfield's Yard is completely out of keeping with the other photographs taken in the city. All the others were of popular tourist attractions in large open spaces and it is difficult to believe that a trip to a murder location connected to Jack the Ripper would have been on the official itinerary. Given the full week in London, it is likely the photographer had some free time and arranged a private cab to take her to see one of the murder locations. At that time it was little more than a decade since the Whitechapel Murders had taken place; recent enough to be titillating, but distant enough to not incur outrage. It must remain a supposition, but there is a possibility that Berner Street was visited just before or after the trip to The Tower of London, a short distance away. It seems unlikely that a whole group of tourists would have disembarked at this point to view the scene, and only one man in the photograph (the one on the far right looking into the camera) appears well-dressed enough to be a tourist. One must also wonder why this location was chosen above the others. Certainly, the places where Martha Tabram and Mary Kelly were killed were deemed unsafe. The site of the Mary Ann Nichols murder was a bit of a distance further to the east and the location of Annie Chapman's murder was in a private backyard. This really only leaves Mitre Square, where Catherine Eddowes died, and here as viable stops. Perhaps she took a cab and visited all the murder locations but only photographed this one? We will never know.

It is unusual that the photographs of Ireland follow those of England, even though the Cook itinerary shows the stops in Ireland coming first. There is a possible explanation for this, the clues coming in the photographer's narrative quite late in the album. Although the ink, browned with age, appears uniform throughout, later entries appear to be written in a smaller and more shaky, angular hand than the earlier comments. She uses the words 'If my memory serves...' by one image of Pompeii and on the next page she writes 'Florentine Palace – the Vectis if I remember rightly, at this writing seventeen years later'. It is unlikely she would have remembered so many details and locations by 1917, probably in old age by that time, and so I have concluded it is likely that the photographs were possibly put into the album shortly after the trip, but that she gave up on writing comments at the time halfway through and finished those years later. The placing of some images out of order may simply be through quickly pasting them down and realising the order in which they should have been put afterwards. Though meticulous in some ways, in others the owner of the album was more slapdash. Nevertheless, almost every location in the album from the 1900 trip is identified.

There is a strong possibility that the photographer had an interest in the darker side of things. When a location has involved death or bloodshed, she has not shied away from commenting on it. In fact, she has made a point of stating the fact. 'The scene of burning of Christian Martyrs' in London, 'Here stood the guillotine during

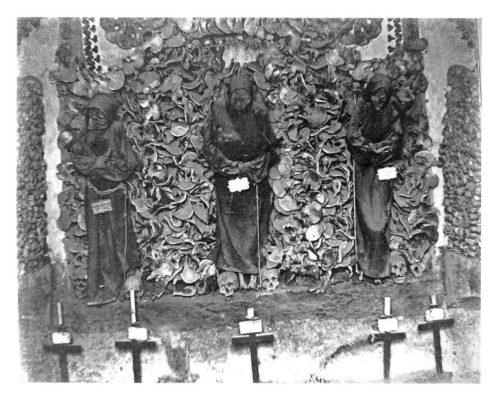

Mummified remains of Capuchin monks, from the album

revolution' in Paris, 'Crypts frescoed with bones of 4,000 monk ...(?) brother amid the skulls' and 'Monks are buried in holy earth from Jerusalem and taken up to make room for fresh corpses' by a photograph of mummified Capuchin monks at Rome, 'Lion's dens, cells of prisoners, Nero's box' at the Coliseum and the graphic 'Plaster cast of body entombed in wet ashes in Pompeii. Plaster was poured into mould left by decay of body. Bones intact. Most victims fell on their faces trying to shield them from the hot ashes' at Pompeii. Such comments may have been thought a little unsuitable for genteel society at the time.

Other comments give an intriguing glimpse into the life of the tourist. The best come from the time in Italy:

'Rag Fair in Rome. Here you might pick up rare antiques or buy a pair of shoe strings. A child here spoke of the 'ara' in my teeth and I had to show my fillings to a crowd of poor peasant people. Had my mouth full of Roman heads'
'Leaning Tower of Pisa. Beautiful alabaster building. Here I lay on my stomach on floor of upper storey and stuck my head over. Horses below looked like mice'
'A couple of handsome gendarmes in Bordighera on the Riviera. The youngest blushed crimson when I asked him to pose. Beautiful uniforms'.

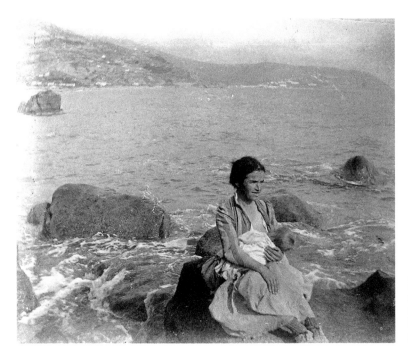

Mother and
child by the
sea in Naples,
from the
album

'Italian mother feeding her bambino on shore of Mediterranean. When I first saw her she was picking 'something' off the head of an older child'

'Public lavatory, Bordighera. Girl of fourteen in foreground feeding her baby. Italian infants were always feeding on cathedral steps and 'all over the place''

However, there was one vivid and extensive entry which would point me in the direction of further research:

'Vesuvius from moving train. An Italian humorist tried to ask me about the ...(?) etc and afterward picked up some manuscripts (I was writing on the train) and pretended to read it to his party, convulsing them with laughter and exciting my curiosity almost fatally. This party urged me most hospitably to partake of their lunch of black bread and odorous cheese'. Part of the text was to lead me down a different type of alleyway to Dutfield's Yard.

Finally, after the Naples photographs, there was no indication of the photographer's return voyage to the US. Further correspondence with Paul Smith at the Thomas Cook Archives was to present this information:

'I am afraid I cannot tell you the name of the ship on which your photographer returned from Europe to New York. However, I can confirm that it would not necessarily have been the 'Lucania'.

We should have more luck with the dates, however. The *Excursionist* states that Tour No 22 lasted 103 days. This gives a return date of 12 September 1900 (or thereabouts).

The itinerary quoted in the 'Excursionist' also shows that Naples is the final port of call before New York. According to timetables in the archives, the shipping lines which operated a Naples-New York service were as follows: Anchor Line; Cunard Line (14 days' journey time); Cyprien Fabre & Co (12 days); Hamburg-American Line (13/14 days); North German Lloyd Steamship Company (13 days); White Star Line (12/13 days). Unfortunately, the 'Excursionist' only shows the North Atlantic routes (between North America and Britain/France) rather than the Mediterranean routes and I do not have any separate timetables or shipping lists from 1900 (1906 is the closest).'

The next stage was, with the information already gathered, to attempt to identify the woman who took the Dutfield's Yard photograph.

Trying to Identify the Photographer

Most of the research since the summer of 2008 has been trying to discover who owned the album and took the European vacation with Thomas Cook in the summer of 1900. As 125,000 Americans took pleasure trips to Europe that year, the words 'needle' and 'haystack' come to mind.

I began by contacting museum services in the US. My only possible starting point at this stage (before the Arizona information was known) lay in the Heinn label at the back of the album and its direct link to Milwaukee. I began my enquiries with Al Muchka of the Milwaukee Public Museum. He suggested I contact Steve Daly of the Milwaukee County Historical Society who, in turn, pointed me to Joe de Rose of the Wisconsin Historical Society, an organisation that was to prove very helpful in subsequent research. Various people working for this group undertook unpaid work to assist in uncovering some of the mysteries that still surrounded the album.

I made further enquiries with Larry Lingle, the original seller of the photographs, as to where he obtained the collection. That was, unfortunately, a dead end as he had himself obtained it by auction on eBay in 2005 and had not done anything with it since then.

Little could be assured about the photographer herself from the photographs. Even her age is indeterminate; she could be aged anything between 25 and 50. She appears to be blonde and is certainly slim. The photographs give her the impression of having been quite tall. She has an elongated face with a very wide mouth, square forehead, high cheekbones and a large but upturned nose. Her head shape is almost masculine.

Only one thing is likely regarding the home address of the photographer – she probably did not come from New York or New Jersey for the simple reason that she took a photograph of the Dewey Arch before embarkation. A local resident would not have photographed something so close to home as the first image in an album documenting a three-month break in another continent.

Above left: The photographer at the colonnades at St Peter's, Rome, from the album

Above right: Detail of the photographer's face

The information that came back from Ellen Engseth about the proliferation of Heinn products throughout the US by 1900 did make a link to Wisconsin appear to be a red herring. However, the staff at the Wisconsin Historical Society were only too happy to continue searching records from the few clues in the album to try and locate the photographer.

Those clues, nevertheless, could be quite telling. Firstly, the photographer herself appears in four of the images. She is only close enough to the camera in two of them to identify her features. What becomes clear very quickly is the fact that she was travelling alone. There are no family members in any of the images. No husband, no children. Being a woman of such considerable means, this would suggest she was either unmarried and from a moneyed family, or was a rich widow. Such independence was to prove helpful in removing a great deal of possible names.

The historian Chris Scott ran a check on an archive of passenger lists on my behalf, using various criteria. It had to give returns within the confines of unmarried women between the ages of 35 to 45 in 1900 whom had travelled on the *Lucania* from New York to the UK. 11 names came back, none of them in June and only two of them being listed as landing at Queenstown (one being an Irish woman landing on 11 May and the other a Miss Rayden, aged 40, a New Yorker almost certainly on the same date – this being the *Lucania's* disembarkation point directly before it

Miss Van Neiukirk and Miss Blake at the colonnades at St Peter's, Rome, from the album

travelled on to Liverpool and then back to New York to collect the Thomas Cook passengers about to take Tour 22). Although these parameters need to be widened, this clearly shows the inefficiency of some online resources, or perhaps the lack of rigour shown in 1900. Of course, it may be that the traveller was married yet making the trip alone and that her age falls outside that range. Nevertheless, a total of 11 names in a year is most definitely a small fraction of what it should be.

Only two individuals are named in the album, both sadly by surname alone. Both are single women; a Miss Van Neiukirk (apparently quite young), and a Miss Blake. The pair are seen standing at the colonnades at St Peter's in Rome, attired to 'pay homage to the Pope'. This photograph appears on the page next to the clearest image of the photographer herself, marked 'Myself, ditto'. This is a contradiction of the earlier statement in the album about 'Christian Martyrs' at Smithfield and would infer the photographer was a Catholic, unless she viewed the opportunity to see the Pope as one not to be missed, regardless of denomination. This is a distinct possibility as Miss Blake holds a rosary and Miss Van Neiukirk and the

photographer do not. Miss Van Neiukirk is mentioned again as sharing a gondola in Venice with the photographer. It is unclear whether Miss Van Neiukirk and Miss Blake were travelling on the same Cook tour as the photographer, or if they simply met her in Italy. As the distance between Venice and Rome is about 250 miles, it is more likely that all three ladies were making the same extended Grand Tour. Sadly, neither of the women produce any results on the Ellis Island website for arrival into the US in September 1900.

Miss Van Neiukirk was to prove an enigma. Dee Anna Grimsrud at the Wisconsin Historical Society undertook some research and found that this was the original Dutch spelling of the name. A few early immigrants from the Netherlands had this spelling but this was usually changed to Van Niewkirk and eventually Anglicised to Van Newkirk. The early immigrants only show up in New York and New Jersey. It must also be considered, of course, that written records of that time – whether they are from the Census, passport applications or shipping lists – frequently record names inaccurately based on their phonetic sound. Of the possible Miss Van Newkirks found on Census returns, two were in New Jersey and six were in Baltimore, born between 1864 and 1878 and most likely sisters. Only one Miss Van Newkirk is listed on the Ellis Island manifests from 1900, that being a Blanch Van Newkirk born in Baltimore on 27 July 1873, giving an age of 27 at the time of the photograph in Rome. She may possibly be the Miss Van Neiukirk who took the trip, yet her arrival back into the US does not tally closely with the end of the European trip. US Census returns do not give the original Dutch spelling of the name for anyone who fits her description. However, there are no Miss Blakes on the Ellis Island manifests for 1900 that fit at all. Attempts to contact Van Newkirks in Baltimore today who have posted their details online in the course of their genealogical research elicited no replies.

When the touring party returned to the US they would have passed through Ellis Island on their way back home very briefly, even as US Citizens. As a result, the names should appear on the shipping manifests held at ellisisland.org. This is a fact that has been confirmed by several official sources. However, the fact that the exact date of return to the US and the ship on which the final trip from Naples was taken is unknown makes identification of the names on those manifests very difficult. There is also the small possibility that when the final journey was undertaken – given that the original trip was postponed by several days at short notice – the ship that was used took a different route and may have even involved a transfer of passengers at a port during the journey. Consequently, every ship landing at Ellis Island with a large amount of passengers over the space of several days has to remain a viable candidate.

The *Lucania* herself shows as docking at Ellis Island on 13 September 1900, within the timescale permitted by the excursion. Nevertheless, she would not have sailed from Naples at any time, serving only the Atlantic route. A list of the Saloon

passengers on this service (leaving from Liverpool on 8 September 1900) was issued to the travellers and a copy of this is available online. The list of 365 names contains 25 women titled as 'Miss' with no one apparently travelling with them. There are a further 13 women titled as 'Mrs' making the voyage alone.

This list is held by the Gjenvick-Gjønvick Archives. The organisation holds approximately 1,000 passenger lists near Milwaukee, Wisconsin. Curator Paul Gjenvick notes that the 'Lucania' list was only a souvenir given to Saloon passengers and really records nothing more than the names of individuals.

From the names mentioned on the Ellis Island shipping manifest for the 'Lucania', five are possible candidates for our photographer. Margaret McMurray (46), a widowed housekeeper of Pittsburgh having travelled from Newry (so thus unlikely), Margaret Simpson (48), a married woman travelling alone from Wisconsin (a possibility), Harriet Mildblood (49), a Philadelphian housewife, Emilie Noren (36), a housewife from Denver and Amanda Samuelson (41), another housewife living in Chicago who had spent 20 years in the US. None of these names actually appear on the souvenir list issued to prominent *Lucania* passengers, however. Indeed, right down the line it appears that no one named in an external source and consequently investigated appears on the Ellis Island manifests. Although US Citizens and most First Class passengers did not have to take the ferry to Ellis Island itself, they were nevertheless all recorded on the shipping lists and thus should appear when searched for.

Of all the ships docking at Ellis Island around that time, by far the most likely candidate for the return voyage (if the ship did indeed travel non-stop from Naples) was the *Kaiser Wilhelm II*, which had indeed just made a trip straight from Naples on 7 September 1900 and docked at Ellis Island on 20 September. This is a week later than the expected return date but the trip had also begun a week late.
The ship was built in 1889, was 450' long, 9,000 tons in weight and could accommodate 1,200 passengers. Though smaller than the *Lucania*, she was nevertheless almost a match in the opulence afforded to its higher-ranking passengers. It was also owned by the North German Lloyd Company, a shipping line used frequently by Thomas Cook. The ship was renamed the SS *Hohenzollern* in 1901, was wrecked in Sardinia on 10 May 1908, refloated and scrapped in Italy.

The major issue with the *Kaiser Wilhelm II* Ellis Island manifest (if the assurances that ALL passengers – visitors, immigrants and Citizens alike – were recorded are correct) is that virtually every name on the list is a foreign immigrant and only one person could possibly be the photographer – a 49-year-old Miss Morgan. Even here, there is a problem as she is recorded as having sailed from Genoa on 6 September, the stop before Naples and the long trip back to the US.

There are four other ships listed at ellisisland.org as having arrived back into New York direct from Naples within the time period, and none of them are likely candidates. The *Spartan Prince* was an immigrant ship owned by the British Prince

Line and it docked on 9 September. The *Archimede* manifest consists solely of Italians and docked on September 16, the same day as the *Bolivia*, with a manifest of a single Italian. The *Werra* arrived at Ellis Island three days before, having stopped at Genoa and Gibraltar en route but only containing four Italian passengers.

Ultimately, the only ship recorded on the Ellis Island manifests at the time of the return voyage holding numerous US Citizens is the *Lucania*. This can only mean one of three things; either the manifests are not complete and do not show all the names of returning passengers, the passengers transferred vessels mid-voyage, or the ship from Naples did not dock in New York at all. Until the answer to this question is known, no further progress can be made with this line of enquiry.

This leaves two further options; photographic identification and coverage of the known outbound journey on the *Lucania* on 2 June 1900. This would be a far less fruitful endeavour as, of course, those leaving the US would not be officially recorded. Nevertheless, options were becoming limited.

One major issue concerning the US Census returns for 1900 is that they began on 1 June and ended on 30 June. Although the touring party left the US a week late,

.

Mr. and Mrs. Clarence W. Mackay will sail for Europe on the Oceanic on Wednesday, June 13. Among those booked to sail to-day on the Lucania are, among others, Mrs. Brockholst Cutting, W. Cutting, E. Coleman, Miss Callender, Miss De Forest, the Rev. Morgan Dix, Miss Dix, Mr. and Mrs. G. W. Davidson, Mr. and Mrs. George I. Eastwick, Frederick B. Esler, P. Fachiri, Mr. and Mrs. Clarence M. Hyde, Miss Clara Hyde, Mrs. Edward Renshaw Jones, Miss Mabel Jones, Henry Janin, W. R. T. Jones, V. S. James, Miss Adele Kneeland, Mr. and Mrs. Joshua Lippincott of Philadelphia, Mrs. H. P. Loomis and son, Mr. and Mrs. F. S. Landon, Mr. and Mrs. Charles Minzesheimer, Mrs. N. S. McCready, Mr. and Mrs. William Noble, F. E. Norton, Mr. and Mrs. F. W. Rhinelander, Count de Rouille, Mr. and Mrs. Arthur H. Scribner, Francisco Terry, Sr., and Jr., and Robert Weir.

.

Cutting from the New York Times of 2 June 1900 *(Courtesy Dr Timothy Riordan)*

they were still only in the country at the start of the Census and thus it is unlikely that any of them will appear on the 1900 return. Initially, this could present a problem but in the long-term may have a benefit; any individual showing on the 1890 and 1910 returns, but not the 1900 one, would be more likely to be the relevant individual.

The historian Dr Timothy Riordan found a small article in the New York Times of 2 June 1900, listing some of the more important travellers on board the *Lucania*. Of the 42 people listed, none of them match names on the 'Kaiser Wilhelm II' manifest but just one, obscure enough to warrant further investigation, matched a name on the souvenir *Lucania* list from Liverpool to New York that departed on 8 September. Recorded as just 'Miss De Forest' (no other people of that name listed) in the New York Times, there is a 'Miss Julia B De Forest' on the returning September list. Miss De Forest may have nothing to do with the Thomas Cook tour, although it is highly likely that she is the same woman mentioned in both the above sources. This is almost certainly the art historian and author responsible for *A Short History of Art* (1881) and, given that there are numerous paintings photographed in the closing images of the book, it may well suggest that she is the photographer. However, further research uncovered the difficulty that De Forest died in 1910 and the owner of the album was making notes in it as late as 1917.

This was not the first time that hopes were dashed. The owner's entry in the album underneath the photograph of Mt Vesuvius mentions that she was writing 'manuscripts' on the train. This seemed a curious turn of phrase to use unless the writings were of a professional and artistic nature and could thus indicate that the photographer was also a known author.

There were a great many women authors working in the US in the late 1800s. Just one list alone of prominent writers of the time names 77 of them. From that list, 44 were dead by 1900. Of the remaining 33, 15 were too old by that date. This left 18 and, of them, nearly all were of the wrong ethnicity, were married or looked nothing like the photographer in online images. There was only one match, and that was the author Lizette Woodworth Reese. Reese was born in 1856, which would have made her 44 at the time of the 1900 trip to Europe. She was a poet from Baltimore (Baltimore, you will recall, having been a likely address of Miss Van Neiukirk) and was unmarried. She was also the first President of the Edgar Allen Poe Society (a possible nod to the photographer's interest in the macabre). A monument in her memory still stands in the grounds of Lake Clifton High School in Baltimore. She died in 1935 and examples of her handwriting do look familiar to the less fluid writing of 1917 by the owner of the album. Most interestingly, a photograph of Reese in old age bore a remarkable similarity in many ways to the St Peter's photograph of the tourist from 1900. By the time I came to lecture on the photograph at the Ripper Conference held in Knoxville, Tennessee in October 2008, I was fairly sure that Reese was the woman behind the Dutfield's Yard photograph.

One further piece of detective work convinced me even more. In one of the later closing images in the album, taken in the US, a little girl stands next to a painting on an easel. In the background is a painting of a grown woman. This picture bore a strong resemblance to the author Anna Katherine Green, born in 1846. Green was largely credited with being the first female crime fiction writer and was sometimes referred to as 'the female Edgar Allen Poe'. I had no idea if Reese and Green had known each other but it all seemed to strengthen the case.

Then a discovery was made which resulted in all these coincidences counting for nothing. The very day before I was due to give my talk, I found two photographs of Reese dating from the early 1900s, and she looked nothing like the woman in the album in any way. Jon Shorr and Jeff Korman of the University of Baltimore provided further photographic evidence of Reese, again in old age, but this time looking far less like the woman from 1900. Ripper historian Chris George is a past President of the Lizette Woodworth Reese Chapter of the Maryland State Poetry Society and he pointed out that Reese was not a rich woman and it was unlikely that she would have made such a journey. Chris felt it more likely that the traveller could have been Edith Wharton or Emily Spencer Hayden, but both of these names were clearly not the woman in the album. The final nail in the coffin came

The author lecturing on the Dutfield's Yard photograph in Knoxville, Tennessee, October 2008

Above: A comparison shot of woman in painting and Anna Katherine Green

Left: Later American photograph of child amid paintings, from the album

Alice Brown

when Timothy Riordan discovered that Lizette Woodworth Reese was at home in Baltimore at the time the Census was taken locally in mid-June, by which time the *Lucania* had just arrived in Ireland.

It is by no means definite that the owner of the album was involved in the arts, but given her disposable income, her eye for photographic composition (historian Glenn Andersson states that many artists of the late 1800s were also keen photographers) and her way with words – coupled with her use of the term 'manuscripts' and the photographs of paintings later in the album – it seems probable that further research in this field may yet yield results.

One further discovery was made which, although not naming the photographer, may give a reason for her lone journey and the presence of two other spinsters.

Alice Brown was a writer, born in 1856 and dying in 1948. She came from New Hampshire and taught there and in Boston before becoming a prolific writer of novels, plays and short stories. Her main home was in Boston but she spent her summers in Massachusetts and at a farm she owned in New Hampshire.

In 1891, along with a friend, a poet and a teacher, Brown wrote a short book named *A Summer in England – a Handbook for the use of American Women* about their travels into Europe. The limited print run of 500 copies sold out in a little

over a month. Following a reprint in 1892, the women began a magazine named the *Pilgrim Scrip*. The purpose of this magazine was to impart advice and facts to women travelling into Europe. It included tips on travel and etiquette and lists of lodgings. Matters progressed and an organisation was formed with membership criteria. This was named the Women's Rest Tour Association, and it was affiliated to the Women's Educational and Industrial Union, founded in Boston in 1877. The central demographic of the association consisted of single, middle-class individuals. When returning to the US, members would meet, share stories, make presentations and pass on information useful to others intending to travel. Subsidies were provided for women unable to fund their sojourns alone. By 1910 the club had 2,700 members, mostly along the east coast. It was nothing more than an additional lead, but there was now a further possibility that our woman, at least middle-class and travelling alone and in the company of two other single women in Italy, was a member of that organisation. If this is the case, she would certainly have been one of the more wealthy members as many women were venturing into Europe at a quarter of the price she had paid. It is sadly almost certainly a coincidence that a picture of Brown in her later years bears a passing similarity to our journeywoman.

One final lead that would have been a superb find but immediately came to nothing was the small possibility the photographer was Kit (Watkins) Coleman, the Canadian journalist who travelled to London in 1891 and wrote detailed reports of how the murder sites appeared in February 1892. She had initially travelled over to report on the gradual disappearance of the London of Charles Dickens but there do not appear to be any photographs from this trip. It was a truly fanciful notion, and the only links between the two visitors was that they were both women from North America who wrote and had visited a site connected to Jack the Ripper.

There are still avenues to explore. The National Archives at Kew hold an extensive (albeit unindexed) library of incoming passenger lists to UK ports between 1878 and 1960. As the ship (the *Lucania*), port (Queenstown) and approximate date (mid-June 1900) are all known, this may yet provide possible answers. John Langley, the Chairman of the Cunard Steamship Society, mentioned that the Cunard archives are mostly held at the University of Liverpool and these, too, may somewhere hold the name of the photographer.

Currently, however, she mirrors the case to which she will now be forever linked. Both research into the identity of the Dutfield's Yard photographer and Jack the Ripper himself lead down countless avenues that contradict each other, provide new clues, stop dead and leave question marks hanging at every turn.

The People in the Photograph

The final remaining untapped area in researching this photo lies in the tentative identification of the individuals shown standing around the entrance to Dutfield's Yard. It's almost impossible that any of them will be truly known but there are

some likely candidates and it is through the work of Tom Wescott and Chris Scott that these names have come to light.

Firstly, a list of the people seen in the photograph. There are, surprisingly, 23 people visible (some almost imperceptibly) as well as two cats and two shadows of people on the left who did not make it into the photograph.

Two girls, possibly around 13 years of age, are on the extreme left. The one closest to the camera is eating something. Both wear knee-length pinafore dresses. Beyond them, a woman in a dark dress has her hand on the second girl down and is peeking at the camera. A boy in a cap and calf-length trousers, moving at the time of the photograph follows. A woman looks down the yard and, next to her, a girl or short woman in a lace-trimmed skirt or dress. A man with a cap and thick moustache looks at the ground and in front of him a small child (about 5 but gender indeterminate) also looks away from the camera. A very Jewish-looking woman is next down, clear and smiling in the direction of the photographer. A man in a cap and jacket stands alone, completely shaded. Behind him, a woman in a full-length dark skirt and apron stands just beyond the gap at the back of 42 Berner Street. In the far background, two men are seen on the upper level of the cabinet makers. Both appear to be dressed the same in their shirt sleeves and wearing (leather?) aprons. One stands outside in the sun, the other inside the doorway.

Coming up the centre of the yard, there are two women facing the photographer just this side of the gap behind 42. The one on the left is taller and is wearing a hat. The shorter one on the right (barely visible) appears bare-headed. There are two cats in the doorway of the International Workers' Educational Club. One is in the yard itself at the bottom of the steps and the other in within the doorway at the top, looking down at the one below. Two children take centre stage. A boy about seven years old (and probably Jewish) stands in calf-length boots, cap and waistcoat with a muffler, his hands in his pockets and defiantly frowning at the photographer with a pout. A little girl about four years of age stands a short way in front of him in a mid-length dress and apron. She appears to have been looking to her right and quickly turned towards the photographer as the photograph was taken.

On the right-hand side of the picture we see possibly the most striking individual in the photograph. A Jewish-looking man in a cap, elbow-length shirt and full apron smiles at the photographer in the mirror image of the woman opposite. He stands with his back to the end of the open gateway, inches from the spot where Elizabeth Stride's body had fallen. The actual murder spot, down to the steps of the club, is clear. It is likely these people knew exactly why this photograph was being taken but we don't know whose idea it was. The photographer is only one option. It could also have been a tour leader, cab driver, fellow tourist or even a local who intercepted her and suggested a quick trip to Berner Street.

There is then a gap, and the next individual seen is just outside the gateway; a small woman in a full-length dark skirt, moving at the time of the picture being

taken. Next is the short man initially mistaken for a child. He wears too-long baggy trousers, shoes with very thin soles, a round-bottomed jacket and a cap. He looks down the yard and his dark short beard is obvious. The next person can only be seen as a few locks of hair. Two individuals away from the camera is the only person in the image who appears affluent. This man's shoes shine, he wears a waistcoat and jacket and has a brimmed hat. His shirt has an upturned collar and he is looking at the photographer. It is possible he was another tourist on the same trip. The final person is a female, possibly a young woman, looking past the well-dressed man down into the yard and wearing what appears to be a dark shawl and a calf-length white apron.

Most people in the photograph look curious or bemused, but the Jewish-looking couple standing in front of the opened gates are both smiling at the photographer. The placing of the pair and the children in the middle (certainly the young boy) make it possible that they were the original individuals who were about to be photographed and that other people in the area, fascinated by a rich American tourist with a camera (perhaps akin to a film crew appearing in your street today), all crowded round to see what was happening and the photographer had arranged them in such a way that they could all appear in the photograph. It is a great shame that, given the copious explanatory notes presented later in the album, the photographer only titled this image as 'Scene of famous Whitechapel Murders London'. Indeed, it is not until she hit mainland Europe that she started giving any account at all.

So, who could these people be? It is fortunate that this photograph was taken less than a year before the 1901 Census in the UK. The Census details for 40 and 40a Berner Street (thus covering Dutfield's Yard, as the next entry is for 42 Berner Street) are nicely detailed and there are several possible identifications for the people in the middle of the photograph. All of them are Russian Jews.

Chris Scott's work on the Census reveals eight households, of which one was a family without a male head and another was a couple without children. The named couples are Benjamin and Sarah Goldberg, Morris and Sarey Sherman, Samuel and Annie Simon, J. and M. Goldstein, Morris and Annie Ringold (without children), Nathan and Rebecca Freedman and Marks and Mary Klone.

The text under the Dutfield's Yard photograph, from the album

From the list, the Shermans, Goldsteins and Freedmans all had a boy that could be the child in the middle of the picture (Raphel Sherman, five in 1900, so unlikely; Jack Goldstein, seven in 1900 and a possibility; and Barnett Freedman, nine in 1900 and also a possibility). The Shermans lived in 40 Berner Street and not Dutfield's Yard. The Goldsteins would have been fifty-three and forty-nine at the time of the photograph, and in the image the woman appears to be in her thirties and the man perhaps about forty (though it can be very difficult to tell).

Nathan Freedman would have been thirty-four in 1900, and his wife Rebecca twenty-nine. Freedman was a plumber and he had three children; Joseph (fourteen in 1900 and listed in 1901 as a blacksmith), Barnett and Polly who was aged seven at the time – probably a little too old for the little girl in the centre, if she is indeed related to the other people.

The Goldsteins, however, whilst seeming older than the smiling pair by the gates, do have children that would fit this boy and girl. J. Goldstein is just listed as a 'traveller' in the 1901 Census and, besides Jack and four older children (three of them adults), there was also a daughter named Fanny who would have been five in 1900.

One further issue is that the boy may not be related to the smiling couple at all, and could be the child of the man in the shadows, who is looking in the boy's direction. Of all the children listed as living in the yard in 1901, Jack Goldstein or Barnett Freedman are by far the best candidates.

As for the little girl, she (if resident) may be Leah Simon (six in 1900), Fanny Goldstein, or – less likely – Polly Freedman.

Of course, the Jewish-looking woman may be married to the man behind her in the shadows and not connected to the man in the apron in any way. It is only intuition that suggests any person in this photograph is connected to any other. The only thing that can be said with certainty is that the two men at the very back both worked for the cabinet makers and the three women in front of them almost certainly lived in Dutfield's Yard.

If the smiling couple are married, yet not the parents of the two children, they could be Morris and Sarey Sherman, or Morris and Annie Ringold (Morris a boot-heeler and the couple aged twenty-nine and twenty-eight in 1900). Of these, the Shermans had six children so the Ringolds are more likely.

Further clues as to the man's identity may lie in his apron. Samuel Simon was a thirty-nine-year-old greengrocer in 1900. If the little girl is Leah Simon, then it is very likely that the man in the apron is Samuel. The Simons lived at 40 Berner Street itself, not in Dutfield's Yard. This would mean, however, that the little boy is not his son. It is perfectly possible that the smiling couple, the two children, and the man in the shadows consist of members of the Simon and Freedman families.

These appear to be the only people that may be tentatively identified. There is no obvious connection between any of the other people in the photograph, some of

whom may not have lived at that address anyway. The two girls on the far left do not instantly look Jewish and may have just come out of the Board School directly behind where the photographer was standing (indeed, being close to midday, this could explain the two boys in the photograph as well).

Tom Wescott came up with an alternative theory. He felt the man in the apron by the gate could be Joseph Chaim Cohen-Lask, who rented the premises at the turn of the twentieth century and taught a Jewish 'Cheder' at the house. Cohen-Lask was an accomplished writer and his daughter later wrote an account of his life. Her name was Rachel Beth-Zion Lask Abrahams and, until research suggests otherwise, if Tom's idea is correct then it is even possible that she is the little girl in the middle.

The murder spot after the removal of a modern flowerbed, April 2009
(Courtesy Tony Brewer)

The site of Dutfield's Yard in the Harry Gosling School, 2009 *(Courtesy Robert Clack)*

Afterword

Whether or not you believe Elizabeth Stride to have been a victim of Jack the Ripper, she nevertheless remains one of the so-called 'canonical five' generally regarded as being a Ripper victim. The Dutfield's Yard photograph was a major discovery on several levels. Firstly, and most importantly, it is the only photograph of the location known to exist. Secondly, it was the last remaining location of a Ripper murder that had not previously been seen photographically, being limited beforehand to sketches and drawings in period newspapers. Lastly, though her identity remains elusive, our photographer may be classed – at present – as the world's first known Ripper tourist. The tens of thousands of people who join guided tours each year to view the locations of the atrocities all follow in her wake, and she had no idea.

Delegates at the biannual Ripper Conference recreate the Dutfield's Yard photograph on the exact spot, 25 October 2009 *(Courtesy Gareth Williams)*